Hecho a Mano

James S. Griffith

Hecho a Mano

The
Traditional Arts
of
Tucson's
Mexican American
Community

The University of Arizona Press

TUCSON

The University of Arizona Press
© 2000 The Arizona Board of Regents
First Printing

♾ This book is printed on acid-free, archival-quality
paper.
Manufactured in the United States of America

05 04 03 02 01 00 6 5 4 3 2 1

Library of Congress Cataloging-in-Publication Data
Griffith, James S.
Hecho a mano : the traditional arts of Tucson's Mexican
American community / James S. Griffith.
p. cm.
Included bibliographical references and index.
ISBN 0-8165-1877-7 (cloth : acid-free paper) —
ISBN 0-8165-1878-5 (paper : acid-free paper)
1. Mexican American folk art—Arizona—Tucson—
Catalogs. I. Title
NK839.3.M4 G75 2000
704.03'68720791776'074791776—dc 21
00-008565

British Library Cataloguing-in-Publication Data
A catalogue record for this book is available from the
British Library.

Publication of this book is made possible in part by grants
from the Southwestern Foundation and the Southwest
Folklore Center of the University of Arizona Library
(Tucson) and by the proceeds of a permanent endowment
created with the assistance of a Challenge Grant from the
National Endowment for the Humanities, a federal agency.

This book is gratefully dedicated to the artists of Tucson's Mexican American community—past, present, and future.

• Contents

• Illustrations

Color plates following page 26

There still stands an historical and venerable house on a corner lot in Barrio Libre—it is a third of a block long and is now divided into apartments. It is almost a century old—constructed of mud adobe with walls a foot thick—Sonoran style, with a flat roof and a plain facade. It is the color of a nopal after a summer rain. Shading the doorway of the main residence is a huge *piocha* tree that in the spring droops with fragrant clusters of lavender flowers. It is the only tree on that block, for the once proud *vecindad* of sturdy homes of some of Tucson's most stalwart Mexican American pioneers is triste now—dominated by empty lots strewn with rubble and weeds, and collapsing and abandoned casas frequented by transients passing the day sitting on the broken stoops.

I knock on the weathered wooden door. Glued to the small windowpane is a poster of a picture of the Virgen de Guadalupe and the gentle admonishment *"Este hogar es católico. No se permite propaganda protestante."* Doña Ramona Benítez Franco is expecting me, for I have made an appointment with her to interview her about her life memories and the history of her family's ranch in the Rincon Mountains on Tucson's far east side. There is no answer. I knock again. I am worried that Doña Ramona will not hear me over the whir of the evaporative cooler in her living room window. At last I hear a muffled shuffling in the *zahuán*. *"Ay voy,"* a voice says pertly, and then she unlocks the door with the clatter of keys and the clicks of multiple bolts.

Doña Ramona Benítez Franco opens the door. Her bright eyes and smooth brown skin belie her ninety-four years. ("The same age as my house," she will tell me proudly on one of my subsequent visits.) She has done up her fine white hair into a cap of soft curls. She is wearing makeup, lipstick, and rouge, and a stylish dress of pink polyester. *"Buenos días. Pase. Pase."* She greets me shyly and motions me inside. I step from the bright light of the stifling August heat into the cool dark zahuán and follow her through a wide arched doorway into the *sala,* my eyes adjusting to the light. I survey the

room, and then my heart leaps with joy—for almost an entire wall of the large room is dominated by a magnificent home altar that is lit up by strands of multicolored, brightly twinkling Christmas lights and decorated with all manner of holiday garlands and tinsel. The centerpiece of the altar is a large painting of the Virgen de Guadalupe surrounded by her court of saints, holy children, and placid virgins—La Virgen del Rosario, La Virgen del Carmen, La Virgen de Perpetuo Socorro, El Niño de Praga, El Santo Niño de Atocha, San Martín de Porres, San Judas, la Sagrada Familia, San José. On the altar are arranged flowers of every hue—fresh and dried, paper and plastic—and novena prayer books worn from decades of use; seashells; vigil lights; rosaries; and dozens of family photographs of children, grandchildren, and great-grandchildren. Overlooking this splendor, as if spiritual guardians, are photographs of great antiquity of Doña Ramona's *antepasados*—her mother and father and long-dead maternal grandmother.

Doña Ramona notices my stunned wonderment as I gaze at the altar and explains that the Virgen de Guadalupe was an object of special devotion of her parents, Angel Benítez and Desideria Vindiola Benítez, at their rancho in "El Rincón" and that they held a *velación* in the virgin's honor on December twelfth, her feast day, every year. Her grandparents, Gabriel Vindiola and Maria Leyvas Vindiola, she goes on to inform me, venerated El Santo Niño de Atocha and held a velación for him at their neighboring rancho each Christmas Eve. And then, to my amazement, Doña Ramona spontaneously sings and recites from memory dozens of verses of prayers and *alabanzas* that she learned as a child while kneeling by the side of her pious *abuelitos* and parents almost a century ago.

It is at the foot of this altar—in my opinion as glorious and powerful as any cathedral—that I will spend many hours in the following weeks as Doña Ramona recounts to me the story of her life and the history of her *antepasados*. This place in this sala in this humble barrio home will become my *querencia*—a fountainhead of renewed faith and enlightenment that will help me understand the importance of originality and spontaneity and creativity and spirituality in our everyday lives.

In the succeeding months I will continue to be surprised and moved by the intricacy and richness and power of Doña Ramona's life—a life surrounded

by unselfconscious art and beauty lived out to its fullest every day. I notice the delicate and finely wrought doilies and scarves on the backs and arms of her Chesterfield sofa and chair and on the coffee and end tables in the living room. "Do you think they're pretty?" she asks.

"Oh, yes," I reply, "They are very beautiful."

"*Un momentito,*" she says. She walks down the wide zahuán and through a doorway leading to another room. I hear her rummaging in the bedroom. "*¿Me puedes ayudar con este veliz?*" she calls down the hall. I follow her voice into the bedroom. She is struggling with a battered suitcase, which she stores under a turn-of-the-century iron bed, the mattress of which is covered with a faded hand-stitched quilt. She tells me in a subdued voice that this is the bed in which she was born at the rancho in El Rincón. Hanging above the headboard is her mother's cherished rosary, with its black wooden beads worn with use, and a *cuadro* of San Ramón Nonato—the patron saint of childbirth—which was given as a gift to Sra. Benítez when Ramona was born. My eyes and my heart are trying to assimilate everything before I am ushered back into the sala. There is another home altar on the bureau—of lesser saints, I suppose—and hanging on the walls are more antique photographs of somber relatives. Suspended from the vanity mirror is an artful arrangement of hats—including a Southern Pacific Railroad hat—that had belonged to her beloved husband, Roy Franco, and had never been removed since the day of his death more than thirty years ago.

In a few minutes I am again sitting on the sofa in the living room, surrounded by dozens and dozens of crocheted doilies and pillow covers and scarves, and decorated hems from clothing and linens, which Doña Ramona has tenderly removed from their tissue-paper wrap. It is as if I had been caught in a sudden August storm of gigantic snowflakes of fantastic designs: angels, flowers, love birds, storks, fruit, and geometric pinwheels.

"My mother crocheted most of these," she tells me proudly. "They are very old, and I have saved them. She would crochet in the evenings after chores to relax. See? She crocheted this pillow cover of a stork for me when our first son was born over sixty years ago. I was never very good at crocheting—she tried to teach me, but I preferred to embroider. I embroidered this tablecloth years ago, but the crocheted hem is my mother's handiwork." She

extends the tablecloth—it is decorated with a garden of flowers of every color of the rainbow embroidered in cotton thread. Last but not least, she tenderly removes her mother's wedding dress from the folds of tissue paper. It is yellowed with age and somewhat deteriorated, but intact—its satin bodice, lace-trimmed sleeves, and many-tiered skirt designed and sewn painstakingly by hand by some unknown but talented seamstress of long ago.

I am never mindful of the time in the presence of Doña Ramona. The morning passes; she generously invites me to stay for lunch. I sit in anticipation at the antique round oak table in the company of two of her sons and a nephew while she busies herself in the kitchen, having politely declined my offer to help. The small dining alcove adjacent to the kitchen is an historical treasure trove of early twentieth-century Tucson. Some of the furniture and artifacts were brought from the ranch. The shelves of the *trastero* and antique buffet are filled with memorabilia—relics of a bygone day—dishes, glassware, trays, urns, ollas, pitchers, kerosene lamps, salt and pepper shakers—all colorfully arranged.

Delicious aromas emanate from the kitchen. She emerges and places a basket of warm tortillas Sonorenses—as thin as organdy and as big as the moon—on the checkered oilcloth on the table. (The basket is covered with a tea towel embroidered with chickens.) She apologizes because arthritis prevents her from making the tortillas herself, as is her wont, but she assures us that she has bought them from a *comadre,* who has cooked them on a wood-burning stove with mesquite wood, in her corral, as tradition demands.

She served us plates of savory *chilaquiles* simmered in a deep red pungent chile sauce and garnished with melted yellow longhorn cheese, frijoles *chinitos*—thrice fried and crisped to perfection—and this summer season's *verdolagas,* stir-fried to a bright green and laced with onion and tomato. I eat two servings of everything, and when I tell her that verdolagas are one of my favorite *antojitos,* she tells me that she gathers them in her back lot and invites me to see her garden. I help with the dishes in the tiny kitchen (in the center of which is a chopping block graced by a large stone, which, she informs me, is her "garlic press"), and then she escorts me out the kitchen door into the backyard.

It is a small oasis of freshness and sifted green light that dispels the

desert heat. There is a rickety trellis with a San Miguelito vine blooming in unbridled pink profusion over the roof. There are bees sipping honey at the pale yellow blossoms of the *madreselva* that is clambering up the clothesline poles. There are climbing roses entwined on the chicken-wire fence, and geraniums bleeding their hearts out in rusty yard cans. There are *tinas* of *yerbabuena,* manzanilla, and epazote. Tomatoes and chiles and cilantro are flourishing in their planters made from discarded automobile tires, and "hens and chicks" are cascading down the sides of an abandoned washing machine that is tilting on three legs. There are variegated petunias flowering in baskets suspended from the limbs of a gnarled mesquite tree and stands of San José silhouetted against the cracked adobe walls of the house. There is a spiky fence of nopal at the rear of the lot, and last, but not least, a centenarian fig tree drooping with purple fruit. It is a garden of delights, as exuberant and magical as any in a fairy tale.

A day spent with Doña Ramona Benítez Franco is a banquet for my eyes and my soul as well as my *panza.* I am full. As I wend my way home in the late afternoon, I hum the tune of an alabanza. And I ponder on the fact that a day spent with her is a triumphant panorama of life as it reflects art, and art as it reflects life, that no interior designer, landscape architect, art instructor, chef of nouvelle cuisine, or philosopher could emulate or inspire. It is a happening—a celebration of *la vida con gusto* that is repeated hundreds of times in the daily lives of *la gente* of the Mexican American community of Tucson. It is an expressed exuberance that arises spontaneously from the wellsprings of heritage, history, culture, and spirituality that is boundless. It brings to our *comunidad* a legacy that is genuine, enduring, and unsurpassed.

Knock on the door of a house on a quiet, unassuming street of our pueblo. It can be a gateway and an *entrada* to experiences and treasures and lessons that are unexpected and unforgettable. You will meet Don Rafael Cruz, now in his ninety-third year, the last of the old-time vaqueros, who learned his trade at the side of his father when he was but a boy of ten. His devoted wife, Elena, will recount his life and trials and show you the horsehair and leather reatas that Don Rafael made as a young man. He is partially blind and deaf, but all the while he is sitting in an armchair, attentive, smil-

ing, pleased. (Señora Cruz herself creates a wondrous assortment of crocheted dolls in her spare time when she is not ministering to her husband.)

You will meet Willie Flores, Jr., an octogenarian who still plies his blacksmith trade at his shop on Main Street—a skill he also learned from his father, Guillermo Flores, Sr. His modest home is embellished with wrought iron fences, gates, *rejas,* and decorative porch supports wrought by his own hand and of his own design.

You will meet Rogelio Valdovín, a retired school janitor, whose magnificent Aztec costumes of fabric and leather and sequins and feathers and miniature mirrors he designed and sewed himself. You will learn that they were inspired by a vision.

You will become friends with Toni Aguilar, whose samplers of *deshilado* are some of the finest to be found north of the border. In one of your visits to her at her far southside home, she will explain that she learned the ancient craft from her grandmother, Antonia Rubal, while living with her at her remote ranch in Aravaipa Canyon. She will tell you that she is teaching needlecraft to her granddaughter and will show you examples of her work that show a high degree of skill for a child only six years old.

You will be invited by Sra. Livia León Montiel, a fifth-generation Tucsonan, to a family reunion at her home in the Tanque Verde area of Tucson. The celebration will last through the weekend. There will be a mass sung to the strains of a guitar, and a dinner served—steaming plates of *barbacoa* cooked in the pit on the property, frijoles de la olla, and fresh salsa de chile verde. There will be a talent show on a makeshift stage—the grandchildren will dance the *jarabe tapatío.* When the crowds have thinned and the evening is quiet, Sra. Montiel will show you a jewelry box made by her mother, Antonia Galaza, in the early 1900s. It is the shell of a desert tortoise, lacquered and lined with cotton and satin and joined with miniature hinges.

You're taking a detour between Grant Road and Speedway in Barrio Blue Moon. You notice a front yard in that humble neighborhood decorated with fantastic statuary and architectural sculptures. You're rushing down 22nd Street to make it on time to the airport. You glimpse an elaborate yard shrine of river stones and colored glass, and you pause to cross yourself and

say a prayer. You are invited to a fiesta, a wedding, a *quinceañera,* or a *bautismo.* The tables are decorated with paper flowers, and the salon is hung with bright banners of *papel picado* made by neighbors and friends; the sartorial finery sewn by an *abuelita* or a *tía.* You go to meet a friend at one of your favorite restaurants on South 4th or South 12th. You slow down to admire a magnificent mural depicting Mexican history, which has been executed by school children under the supervision of a local artist. You're invited to Christmas dinner. The tamales are sculpted of masa as perfect and white as marble. The dessert is a lavish meringue the colors of the Mexican flag. You attend the cathedral *posadas.* The *nacimientos* at house after house rival one another in their intricacy and splendor; the procession of chattering children—angels and shepherds—delight you in their homemade costumes. *Biscochuelos* and foaming cups of cinnamon-laced Mexican chocolate are ambrosial in the crisp and starlit December air. You visit a local supper club for an evening of mariachi music and dancing. You will be greeted by Doña Julia Vélez, now past her eightieth birthday. She is sitting behind the reception desk, assisting with hostess duties in the restaurant owned by her sons. She is crocheting a hem for a tablecloth that will be a gift to her daughter. She will sell you *cascarones* with whimsical faces—clowns, charros, señoritas, Teenage Mutant Ninja Turtles—that she creates in her spare time. You go to visit Frank Escalante at the remnants of his nineteenth-century family homestead beside the Río Pantano. You will sit in his backyard and sip lemonade while he explains proudly how he constructed his rambling ranch-style home out of salvaged bricks and lumber. You will admire his horseshoe sculptures and be bemused by the ingenuity of the garden furniture he has welded together from cast-off automobile parts. He will take you on a tour of the place. He has built a small arena where he has family rodeos. On the walls of the weathered barn he has nailed historical ranching implements handed down in his family: wooden saddles, bridles, spurs, cast-iron pans, scythes, reatas. He will tell you that a professor from the university wanted to buy his antiques, but there are some things in life that no amount of money can buy. . .

There are no ordinary days and nights here in our pueblo of Tucson, amigos. Knock on a door. Keep an open mind and an open heart and open

arms. It can change your life as it has changed mine. And the *grito* of joy and discovery and celebration will arise from the depths of your souls. ¡Viva Tucsón! ¡Y vivan los Tucsonenses!

Patricia Preciado Martin

• Acknowledgments

This book is one result of the exhibition *"La cadena que no se corta: las artes tradicionales de la comunidad méxico-americana de Tucson* / The Unbroken Chain: The Traditional Arts of Tucson's Mexican-American Community,"* held at the University of Arizona Museum of Art from November 2, 1996, through January 14, 1997. Fieldwork for the exhibition, including photography and interviews, was done by me and Cynthia Vidaurri, a professional folklorist then from Texas A&M University, Kingsville, and currently employed by the Smithsonian Institution in Washington, D.C. Rosalita Ayala of Tucson served as community consultant for the project, and Peter Briggs of the Museum of Art supervised the organization of the exhibition itself. Tucsonan José Galvez documented the project with black-and-white photographs. The five of us worked as a team; many of the ideas expressed in the exhibit and in this book were the result of group discussions, and many of the interviews were done and much of the data gathered by other people. For that reason I use the first person plural, when appropriate, throughout this book.

A word should be said concerning our research methods. I had been working in the community since 1974, seeking out craftspeople for a regional folklife festival and documenting traditional arts in a more or less random fashion. When Cynthia Vidaurri came to the project, we used four basic strategies to locate additional artists. We cruised the streets of South Tucson[1] and Tucson's southwest side looking for interesting stores, murals, and front yards. We asked the people I already knew to suggest other people whom we should interview. We went on Spanish-language radio and explained our project, asking interested people to call us. Finally, we went to the Yellow Pages of the local telephone directory, especially for such commercial crafts as ironwork and boot making. Each of these strategies paid off in vital contacts. As our knowledge of the community grew, so did the network of people to whom we could go with questions.

Like the exhibit, this book deals with the traditional arts of Tucson's Mexican American community, that is, objects of some impact that are produced by members of that community, conform to community aesthetic standards, and serve some purpose related to the community. Many of the objects discussed here are utilitarian: burglar bars and grave markers, boots and furniture, *cascarones* and piñatas. Although they are made to be used, they may also be highly effective visual objects. A step away from this directly functional material lie assemblages such as front yards and altars. Although these assemblages often have a high degree of visual impact, they, too, are functional. Front yards serve as statements of cultural identity; within the house, altars serve as a kind of communications station between the occupants and the spiritual world.

Other objects, such as low-rider cars and bikes, murals, and prisoner drawings and tattoos, seem more in line with the commonly understood definitions of art; they seem to have been produced primarily as forms of visual expression. If one looks at them more closely, however, one finds that each of these genres also has its social, its community, function. Each serves the community by advertising the community's presence to the outside world and by reinforcing its values internally. In addition, each art form depends upon tradition and precedent for much of its appearance and many of its functions.

This book is not intended as a buyer's guide. Some of the people who appear in these pages have since died or are no longer active; some of the businesses have closed. Other artists and other firms have replaced them. The book, rather, is intended to serve as a report of what the traditional arts of Tucson's Mexican American community looked like at a certain time to a specific group of investigators. As I write these lines in the autumn of 1998, many details have changed since the original fieldwork on which the exhibition and book were based. In a few cases I have added material to bring the work up to date. The patterns and categories I have described, however, remain. I suspect they will remain for many years to come.

No project such as this would be possible without the assistance of a great many people. We wish to thank the following artists and other individuals who helped in the project: Dan Aguilar, Toni Aguilar, Veronica

Ahumada, José Eduardo Alcoverde, Alicia Alvarado, Eddie Álvarez and his family, Aurelia and Gilbert Araneta, Irma Armenta, Martín Barreras, Juan de la Cruz, Frieda Bornstein de Duarte, Estela Federico, Luciano Valencia Figueroa, William Flores, Jr., Ramona Franco, Berta Gamez Gallejo, Jesús García, María Antonia García, María Helen García, Lou Gastelum, Alejandro Gómez, Henry "Bambi" Gómez and family, Carlos Gonzáles, María Gonzales, Loma Griffith, Joe Hernández, Joseph Michael Hernández, David La Roque, Efrén Lazos, Judge Armando de Leon, Paul Lira, Josefina Lizárraga, Luis Maldonado, Sally Marmion, Eva Martínez, Luis Mena, *la familia* Mendívil/Olmedo, Sylvia Miranda, Angela Montoya, Lucrecia Montoya, Richard and Carmen Morales, Juan M. and Mike Ortiz, Estevan Osuna, the Samuel Paz family, Antonio Pazos, Ysidra Peralta, Rosita Pimbres, María de Jesús Robles, Armando Rodriguez, Ignacio Fereira Rodriguez, Javier Rodríguez, Guadalupe Rubio, Lupita Rubio, Carlos Serrano, Eva Strickle, Anthony Terán, David Tineo, Rogelio Valdovín, Luciano Valencia, José Villalpando, and Beto Vizcarra.

We also wish to thank the following businesses, clubs, and organizations: Alexia's Bakery; ¡Aquí Está!; Arroyo Design (Stephen and Elaine Paul); Asociación de Charros de Tucson; Buen Estilo Bike Club (Danny Carrillo and Joe Villa); Las Camaradas Bike Club; The Diocese of Tucson (Bishop Manuel Moreno); The Dukes Car Club (Sandra Doerr); La Fama Bakery; La Jaliciense candy factory (Leonor and Armando Hurtado); KUAT-TV; radio stations KQTL and KXEW-AM; Raza Unida Car and Bike Club (Lillian Robles); Ritchie School Parents' Group; Ronquillo's Bakery; San Xavier del Bac Mission; Sweet Image Bike Club (Eric Dominguez); and El Triunfo Bakery. Thanks, too, to Paul Burkhardt, who pitched in on the computer.

Others who helped the project include David Burckhalter, Ernesto Portillo, and The Center for Creative Photography at the University of Arizona. To all these people and to those we failed to mention, a deep and heartfelt thank you.

Hecho a Mano

I · The Community

I was interviewing Matilde Santa Cruz, a Tucson woman who makes the wonderful, huge flour tortillas that are a culinary specialty of southern Arizona and northern Sonora. We were in her backyard in southwest Tucson, standing by her outdoor stove. Mesquite sticks were burning in the stove, and the *comal*, or griddle, was just the right temperature. She was effortlessly creating the huge, flat tortillas, flipping them back and forth over her arms, while she explained to me how she had learned her skills. "I learned from my mother," she said, "and she learned from her mother. And I've taught my children." She paused for a moment to consider. "It's a chain that will never be broken."

The traditional arts of Tucson's Mexican American community form an unbroken chain linking the Tucson of today to the deep past, the heritage, of its people. Traditional arts are the aesthetic output of a particular community. Some traditional arts are created for use within the community, or indeed, within the family. Others are exported beyond the community to the world at large, serving as symbols of cultural identity. Still others are adaptations of older traditional art forms that have changed in response to the pressures of contemporary life. All have solid roots in the past and in the traditional aesthetic of the community they serve; none are precisely as they were a hundred years ago.[1]

For many people, the phrase "traditional arts" refers to *things*—to objects that can be displayed in a museum or gallery. This book moves beyond those things to such ephemeral art forms as music, dance, food, and even the creation of events. All these art forms, and many more, enrich the community that nurtures them, and beyond that, they enrich Tucson as a whole. In fact, they contribute much of the cultural flavor that defines Tucson for the world beyond. But to understand these arts, we must take a look at the community that produces them: los mexicanos de Tucson, also known as "los Tucsonenses."

A word about terms. In contemporary Mexican American usage, barrios are neighborhoods. They have traditional names and boundaries, and most residents of a given barrio know which barrio they live in. The word "barrio" does not imply "slum" or "ghetto," but simply a Mexican American neighborhood. Many traditional barrios are found on Tucson's west and southwest sides. They have names like Barrio Anita, Barrio Hollywood, Barrio States (so named because it contains many streets with names like Nebraska and Wisconsin), and even Barrio Sin Nombre (Barrio Without a Name). Many younger Mexican American professionals have moved to a midtown neighborhood that is known to many of their friends as Barrio Volvo.

Much of the art discussed in this book is made and used in Tucson's older barrios and gives a special visual flavor to those neighborhoods. When discussing human culture, however, one seldom deals with hard-and-fast rules. Some of the artists discussed in these pages live on the far northwest side, or west of San Xavier Mission, or in midtown neighborhoods. The title of the book is intended to be general and descriptive rather than restrictive.

Finally, I will use "Mexican Americans" to refer to people of Mexican descent and culture living in the United States. "Mexicans" will refer to citizens of Mexico. I will use "Mexicanos" as a cultural term referring to individuals of Mexican descent and culture living on either side of the border. "Chicanos" is reserved for those younger Mexican Americans who identify to a greater or lesser degree with the social and political aims of the Chicano Movement that developed in the 1960s.

Los Tucsonenses

Tucson was founded in 1775 as a *presidio,* or cavalry fort, of the Spanish army. It was placed on the east bank of the Santa Cruz River, opposite an O'odham settlement called "Schuk Shon," or "Black at the Base." This name was borrowed and adapted to Spanish tongues for the new settlement. Tucson remained a part of the Spanish frontier until Mexico gained its independence from Spain in 1821. Throughout this period, and the Mexican period following it, Tucson was a fortified frontier outpost, often barely holding its own against the attacks of the Apaches. Located twelve miles north of one of the gems of frontier Spanish baroque church architecture, Mission San Xavier

del Bac, Tucson continued to be a collection of one-story adobe houses that was served by a chapel within the presidio walls. Directly across the river was the mission church and *convento* (whose last traces were destroyed in 1956 to create a landfill) that served the O'odham village. In 1853, with the Gadsden Purchase, Tucson became a part of the United States.[2]

In some ways, the history of Tucson's name reflects other aspects of the community's history. While the original O'odham name, referring to the black volcanic rocks at the foot of what is now Sentinel Peak or "A" Mountain, was retained for the Spanish community on the east bank of the river, it was pronounced in a way more suitable for Spanish speakers: "Tukson." That this pronunciation continued after the Gadsden Purchase is obvious from the spelling of the town ("Tuxson" or "Tukson") in mid-nineteenth–century diaries and letters.[3] At some later point, probably around the time of the arrival of the transcontinental railroad in 1883, the pronunciation changed to a soft "c," while the spelling remained the same. This was probably an attempt to make the name of the rapidly changing community seem more "American," to make the sounds flow more easily across an English-speaking tongue.

As the name changed, so changed the community. In the 1850s through the 1870s, the dominant families were Sonoran frontier folk, handy with a rifle and used to the hardships of a desert community that was engaged in intermittent warfare with an able and implacable enemy. Everything in town was either created on the spot or freighted in huge wagons across one of North America's harshest deserts—the Sonoran Desert. The Mexican port city of Guaymas, Sonora, was closer to Tucson than any city in the United States, and Tucson was an essentially Mexican town into the 1880s. With the arrival of the railroad in 1883, the balance changed. Tucson was suddenly in communication with Chicago, the cities of California, and points between. American manufactured goods and sawed lumber became readily available, making it possible for new buildings to reflect national trends within the United States. Anglo Americans looked forward to eventual statehood and gained control of the sources of power in the community. Tucson's Native American and Mexican roots were still there, as was evident in the town's name, but as in the case of that same name, they were increasingly less recognizable under an Anglo American veneer. Tucson, for the first time, became a

part of something called "the Southwest." For centuries, of course, it had been part of the northwest—of Mexico, of New Spain, and of the urban native cultures of the Valley of Mexico. Now the balance had changed for the foreseeable future.

Unlike most other growing towns and cities along the border, Tucson had, and continues to have, a Mexican elite. This elite group was composed in those days of merchants, freighters, landowners, and other solid citizens. Although the Anglo establishment had basically gained the balance of power by the turn of the century, this elite persisted, grew, and changed its nature as the community itself changed. The result has been that Anglos in Tucson have always had to reckon with prominent citizens who possessed Mexican linguistic and cultural roots—Mexicano citizens who simply could not be ignored.

Another dynamic came into play shortly after Arizona gained statehood in 1912. Tucson was a railroad town in the American Southwest, a region that was rapidly gaining a reputation throughout the rest of the country as an exotic tourist destination. Not so much so, perhaps, as Santa Fe; the brutal Sonoran summers saw to that. But the desert, the clear, dry air, and the presence of an exotic understratum of Mexicans and Indians all provided lures for potential visitors and seasonal or even permanent residents. The story of El Tiradito, Tucson's "Wishing Shrine," serves to illustrate my point.

On April 1, 1893, a short article in the *Arizona Star* mentioned a shrine to the southwest of downtown Tucson dedicated to the soul of a murdered Mexican. This is the first known reference to what later became known as El Tiradito—a site that is still used for petitions to the spirit of the unknown person or persons who, according to legend, were murdered and buried where they fell. What appears to be the same shrine was mentioned in a 1907 diary, with little indication that it was of real interest to anyone other than laboring-class Mexicanos. Then, in 1927, a road-widening project caused the shrine to be obliterated. Land for a replacement shrine was donated to the City of Tucson by Teófilo Otero, a member of one of Tucson's established Mexican elite families. An "official legend and story" was adopted by the City Council. A few years later, an article in *Progressive Arizona* gave several alternate legends on the origin of the site, all collected by the Anglo author from other

Anglos and Europeans (including Bishop Jean Baptiste Salpointe, a Frenchman).

What was going on here? Apparently, once Arizona was safely established as one of the United States, once its "American" character was no longer in doubt, Mexican folk culture could be viewed as a saleable part of local color rather than as an impediment to progress. El Tiradito still exists, more than a hundred years since its first public mention, and candles are still lit and placed at the site. It is used by Mexicans and Anglos for religious petitions, has been declared a National Historic site, and is a cultural landmark to which Tucsonans take visitors.[4]

The twentieth century brought other changes to Tucson. The nineteenth-century Mexican elite of frontiersmen and traders had been replaced to a great extent by businessmen. Among the families that came into prominence at this time are such locally familiar names as Jácome and Ronstadt. Many families had well-established roots in both Sonora and Arizona, and for these people, the international border was a relatively unimportant line that produced only a slight inconvenience. In addition, Tucson's proximity to Mexico, combined with the unsettled conditions brought on by the decade of the Mexican Revolution between 1910 and 1920, assured a constant inflow of Mexicans of all classes seeking the security of the United States. This process of immigration and absorption of the immigrants into Tucson's Mexicano community continues to this day.

But life in Tucson was less than idyllic for its Mexican inhabitants. Subtle and not-so-subtle discrimination reminded them in a multitude of ways that they were in fact an ill-regarded minority in the rapidly growing, mostly Protestant, English-speaking city. Aside from the relatively few Mexican elite families, most Mexicanos belonged to the laboring classes and lived in neglected enclaves with substandard urban services and less-than-sympathetic teachers and public servants. Even through this period of discrimination and hardship lasting from the 1920s to World War II, however, most Tucsonenses did not suffer the open oppression that was visited on Mexicans in most of Texas or the race riots of California urban centers. For much of the period, there was some sort of Mexican elected presence in the city or county government.

Nor was Mexican culture totally ignored or relegated to a colorful local tourist attraction. Beginning in the 1930s, Marguerite Collier, a teacher at Carrillo Elementary School, on Main Street, engaged her students in the Mexican Culture Club, teaching *folklórico* dancing and instituting the Christmastime *las posadas* processions commemorating Joseph and Mary's search for shelter. Another teacher, Eulalia "Sister" Bourne, dressed her rural students in sombreros and encouraged them to participate in such public events as the annual Rodeo Parade (then, as now, an important late-winter spectacle in Tucson), singing Mexican songs.

Both women were moved by a desire to instill the pride of cultural identity in their students as a step toward teaching them the regular school subjects. Both groups of children performed for Tucson's winter residents, frequently affluent Easterners, who were fascinated by these "colorful" and less-than-threatening manifestations of another culture.

Art in the Mexicano Community since the Depression

Nineteenth- and early twentieth-century Tucson doubtless had traditional artists in its Mexicano community. But it is only during the Great Depression—which Tucsonenses called "la crisis"—that names, faces, and specific works of art start to appear in the record. Some of the artists were professional craftspeople who used their skills for social and decorative purposes as well. Ulpiano V. León worked with cement during the 1930s and 1940s and was called upon to create small pieces of outdoor furniture and grave markers for use by fellow community members. His work can still be seen in Tucson's Holy Hope Cemetery and in Nogales, Arizona. He filled an important role for his family and neighbors by creating affordable, aesthetically pleasing, and necessary objects on request.[5]

Another man who moved beyond the limits of his craft to create art was the blacksmith José Dolores Santa Cruz. Among other jobs, he set up his forge on the grounds of the new Veterans Hospital on South 6th Avenue and did all the ironwork that was needed for that construction project. In his spare time he would roam the desert nearby, picking up old tools, wagon tires, spurs, frying pans, and other relics of bygone life and work. In his home blacksmith shop he would assemble these into wonderful mobiles that deco-

rated his front yard, making mute statements of place and heritage to pass-ersby.[6]

Some of the art that was created in Tucson was religious and highly personal. Felix Lucero, of Mayo Indian descent, served in France during World War I. Wounded and cut off from his outfit during a battle, he promised God that he would dedicate his life to religious work if he were spared. He managed to make it back to his lines, and the fulfillment of his promise brought him eventually to Tucson and to a permanent place in our community's consciousness.

Living in a cardboard and scrap-wood shack under the old Congress Street Bridge in the 1930s and 1940s, Lucero created sand sculptures with religious themes. Bystanders would toss small coins to him, providing him with the wherewithal to buy food. Eventually, Lucero got cement donated by a local building supply company and created permanent statues. His four life-sized groups of the Life of Christ—the Holy Family, the Last Supper, the Crucifixion, and the Entombment—became the basis of the sculpture garden that is now officially called Felix Lucero Park, popularly known as The Garden of Gethsemane. After Lucero's death in 1951, it came to be administered by the City of Tucson's Department of Parks and Recreation and maintained by volunteers of the Knights of Columbus. Lucero was also invited to create the still-standing cement sculptures at the peace shrine of Saint Joseph the Carpenter in Yarnell, Arizona.[7]

Although the Garden of Gethsemane is a citywide landmark and the subject of postcards and occasional magazine and newspaper articles, it is also important to the mostly Mexicano westside neighborhood where it is located. It is there, for instance, that legends are told concerning the fatal accidents that happened to drunks and others when they mocked the statues as Lucero was working on them. Today, the park is frequently used for weddings and *quinceañeras*.[8]

Like Ulpiano V. León and José Dolores Santa Cruz, Lucero basically "did his thing," independent of market needs. These three artists are representative of large numbers of other traditional artists whose names did not become community property, and who busily decorated the lives of Tucson's Mexicano community in past years. They cooked, embroidered, created home

altars, sang songs, and decorated houses and yards according to traditional formulas. They plastered, worked iron, made spurs and saddles, and braided leather horse equipment. They created christening gowns, wedding dresses and cakes, and grave markers. Their music and songs made celebrations happier, ceremonies more solemn, and funerals more bearable. In other words, they did all the things that men and women do to make their world a little more beautiful, their communities a little more livable.

They were not the "anonymous folk artists" of popular stereotype. They were known within their communities, and many are still fondly remembered by their families. However, they functioned outside the publicized mainstream of Tucson's Anglo world, and they didn't come to the attention of the newspapers and publicists of the time. The patterns they established, like those of the better-known artists mentioned below, still persist in Tucson's Mexican American community.

At the same time that these men and women were enriching the fabric of daily life for their families and community, another group of artists was adapting traditional Mexican forms of expression for "export" to the Anglo community. Such an artist was blacksmith Raúl Vásquez (fig. 1), whose work from the 1940s and 1950s may still be seen at San Xavier Mission. It was said of Vásquez that in his hands iron was as malleable as clay. The snake-shaped handles of the mission's front door are his, as is the mouse on the inside doorplate, and a truly magnificent towel-holder in the shape of a horse's head, tucked away out of general view in the mission's sacristy. Vásquez also produced candlesticks and andirons for many of Tucson's more affluent winter visitors and full-time residents, and his work inspired later generations of ornamental ironworkers.

Vásquez was by no means Tucson's first ornamental ironworker, as the magnificent eighteenth-century baroque filigree crosses on San Xavier's dome and west tower amply testify. Metalworking skills were essential to the community's survival from the earliest days, and talented blacksmiths could— and doubtless did—serve their neighbors in aesthetic as well as in functional ways. But Raúl Vásquez is the first one we know about, the first who has a name, a face, and known surviving work.

Emilio Sánchez Eldridge was born in Mexico City around 1890 and

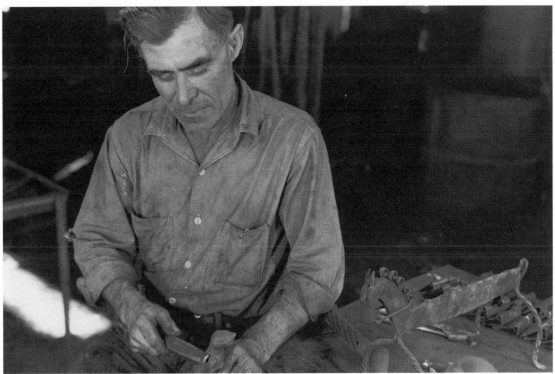

1 The late Raúl Vásquez creating a lizard in his smithy, probably in the 1940s. Photo-
graph by Gene Magee. (Courtesy of the Gene Magee Collection, Special Collections, the
University of Arizona Library, Tucson.)

was adopted by an Anglo family when he was about fourteen. He lived with
his adoptive father, David Eldridge, in El Paso, Texas, until just before World
War I. He served in the infantry during that conflict. Later, in Tucson, Eldridge
was employed at Davis-Monthan Air Force Base.

According to his family, Eldridge supported himself as a young child in
Mexico City making paper cuttings and selling them on the streets. In Tuc-
son, he continued his craft for his family and friends, often enlivening festive
occasions by making paper cutouts and caricatures. He also started cutting
thin sheets of copper and began creating desert scenes, complete with cactus,
wild animals, cattle, and vaqueros, all in silhouette. Not only did he fill his
home with these elaborate cutouts (fig. 2), he also sold them as tourist novel-
ties at Tucson's Mission Drug Store. His highest price was three dollars, less
fifty cents commission. He gave well-attended public demonstrations of his

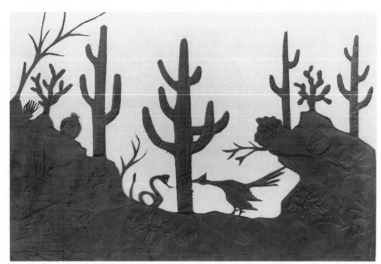

2 Copper cutout by the late Emilio Sánchez Eldridge. Photograph by David Burckhalter.

art at Steinfeld's Department Store and at the Pima County Fair. He became a well-known and much loved local figure, dying in Tucson in 1973 at the age of eighty-two. In 1980, the Tucson Museum of Art presented a retrospective show of his work.[9]

Eduardo "Lalo" Guerrero was born in Tucson in 1916 and grew up in the barrio currently called Barrio Viejo or Barrio Histórico, just south of the present site of the Convention Center. He was one of twenty-seven children, eight of whom survived infancy. His mother, Concepción Guerrero, was a traditional singer and guitar player. Lalo learned the rudiments of the instrument from her, and he learned more from his cousin, Danny Guerrero, when his father attempted to relocate to Mexico City in 1933. Returning to Tucson later that same year, Lalo dropped out of high school in order to earn money by playing music. With three other lads, he started a group called Los Carlistas, which achieved a degree of local success. In 1937, they decided to try their luck in Los Angeles. They found jobs performing, recorded for the Vocalion label, and even landed a small part in a Gene Autry movie. Returning to Tucson as conquering heroes, Los Carlistas were subsidized by the Chamber of Commerce for a trip to New York in 1939, where they appeared on a Major Bowes radio program.

Soon after, Lalo Guerrero moved to California, where he has lived, for the most part, ever since. He became the best-known Chicano composer of

his era. Extremely prolific, he wrote songs in Spanish, English, and the pachuco street dialect that was fashionable along the border in the 1940s. He had several hits in the mainstream Mexican music industry, including the bolero "Nunca jamás," which was recorded by the Trio Los Panchos and several other popular groups. He also wrote highly popular songs in pachuco and a series of parodies of English-language hits, which were widely known and loved among Mexican American audiences. He owned a Los Angeles night-club, Lalo's Place, for many years and fronted his own big band. He always wanted to break into the mainstream of American popular music, but his Mexican ethnicity pushed him into the specialized niches he has filled so well.

Now retired near Palm Springs, Lalo Guerrero still makes public appearances. He has appeared regularly on the popular Paul Rodriguez television show, and his pachuco compositions were featured in the movie *Zoot Suit*. He returns to play occasional concert dates in Tucson, where he has friends and family, and where he is still considered a part of the community. Although his most loyal audience has always been Mexican American, it has grown in recent years to include a large number of Anglos.[10] Regional and national honors have started coming to him; in 1989 he received the National Endowment for the Arts' prestigious Heritage Award, and in 1997 he was awarded the National Medal of the Arts.

William García went to work as a salesman at Myerson's shoe store in downtown Tucson in the 1930s. His young wife, Artemisa, was an excellent cook from a large family, and she would prepare him huge lunches featuring traditional southern-Arizona Mexican foods—tacos, enchiladas, and home-made *caldos* or soups. His fellow workers, most of whom were bachelors, made do with bologna sandwiches, and looked on enviously as he was unable to eat all the food his wife had prepared. Soon he found himself selling a taco or two for small sums of money. He then began to take orders. His wife, flattered that people wanted to buy her cooking, happily adjusted to her new role. Within a year, Mr. García had left his job at Myerson's and was running a full-time lunch-to-order service in a rented former Chinese grocery. From the start, the meals featured tortillas made by Mrs. García.

The family business slowly evolved into Tucson's largest tortilla factory,

which functioned until 1994 under the name La Suprema and is now La Buena. As the business grew and the equipment became available, the Garcías mechanized the process. In 1994, La Buena turned out an estimated 10,000 dozen corn tortillas daily, and also sold flour tortillas, *masa,* and prepared Mexican food from its 22nd Street store. The business is still in the family, with a grandson managing the corn tortilla operation.

Each of these traditional artists—blacksmith, paper cutter, musician, and cook—started out with a highly traditional art form that had existed for years within the Mexican and Mexican American communities. Each one moved from serving the Mexican community to supplying a larger, culturally mixed community with a product that needed to be slightly modified when it crossed cultural boundaries. Each one maintained important aspects of "Mexican-ness" in his or her art, however, and eventually each became an important figure in postwar multicultural Tucson.

That the need for some sort of adaptation was real is evident in the family stories told about the early career of Don Nicolás Segura, an immigrant from Mexico and the founder of Tucson's well-known Poblano Hot Sauce Company. In the mid-1920s, before Don Nicolás started marketing the salsas his father had taught him to make, he operated a taco restaurant. In fact, his family credits him with introducing the folded taco to Tucson! To convince his prospective Anglo clientele to try the then-unfamiliar food, Don Nicolás offered a free glass of root beer with every taco sold.[11]

The artists and works that are featured in this book tend to fall within the continuum we have established through these few examples. Some of these artists work completely in the context of family and community, whereas others serve a broader cultural cross-section of Tucsonans. Some pursue their art form as it was handed down to them. Others work with forms that have been deeply modified, adapted, or even invented in response to changes in the cultures that use or produce them. In some cases, the skills used to produce the objects are traditional, while the objects themselves are not. In other cases, the art form is very modern, but it reflects a highly traditional aesthetic sense within the community. Nothing about culture is simple, and the traditional arts of Tucson's Mexican American community certainly reflect that fact. But they are very real, very present, and very exciting. And each, in its own, distinctive way, is *muy Mexicano.*

II · The Arts

The traditional arts of Tucson's Mexican American community are intricately intertwined with the life of the culture that produces them, and it is in the context of that life that they are best understood. For the purposes of this book, that context is best dealt with in three aspects: *el hogar* (the home), *el taller* (the workshop), and *la comunidad* (the community).

El Hogar/The Home

Life for most traditional Mexican Americans in Tucson begins and ends in the home. For many members of the older generations, this is a literal statement: they were born at home, rather than in a hospital, and they intend to die at home, surrounded by their families. Furthermore, it is in the home where the important institutions and activities of living are located: the family, the home altar, the small ceremonies of daily life. This is more intensely so in traditional families, especially for the women of those families, but it can also be said to hold more or less true for the entire community.

Deshilado and Other Handwork

The home is the woman's domain. Her power reflects and is reflected by that of the beloved figure, Our Lady of Guadalupe.[1] It is not surprising that many of the traditional arts associated with the home are associated with women. Many of these art forms involve handwork. Working with cloth is arguably less common in all parts of society today than it was before 1945, but various handwork traditions survive in Tucson's Mexican American homes. Most artistically and visually striking of these traditions is *deshilado* or drawnwork.

Deshilado literally translates as "removing threads." It is also called *calado*—"pierced work." An openwork design is created in cloth by cutting out individual threads and binding the edges of the space thus created. It

often goes hand-in-hand with embroidery, usually white-on-white, but sometimes involving other colors of thread as well. Napkins, tablecloths, and elegant handkerchiefs are among the objects traditionally created.

If one brings up the subject of deshilado among a group of Mexicanas today, one frequently gets the response, "Oh, my grandmother used to do that. It's a lot of work, and I don't think anyone does it anymore." In fact, although deshilado has become a rare art form in Tucson, there are at least two women locally who actively pursue this skill.

Toni Aguilar learned deshilado (fig. 3), crocheting, and embroidery in her teens from her grandmother, Mrs. Antonia Rubal. Mrs. Rubal lived in Klondyke, Arizona, before moving to Tucson in her later years, and is remembered by her granddaughter as always doing something with her hands. Toni used to love to watch those hands working and tried to learn as much as she could from her grandmother. She is sorry she didn't learn her grandmother's other two handwork skills—knitting and tatting—as well.

Toni Aguilar has made traditional handwork an important part of her life. She uses her deshilado skills to make baby things and bridal handkerchiefs as gifts for friends, relatives, and godchildren. She says that "it's great therapy. It's the best way to get over hurt, anger, or pain." Her grandmother taught her this as well—whenever things weren't going well, her advice would be to "sit down with your work and act like a lady." Deshilado for Ms. Aguilar is more than a useful skill for creating lovely things, it is also a survival technique and a way of linking herself to the values of a much admired person—Doña Antonia Rubal.

Sylvia Miranda was born and raised near Guadalajara, Mexico. She learned to do deshilado as a child from her family and from the nuns in school. She would apply herself diligently to creating lovely things and sell them to buy clothes and shoes for herself and her siblings. When she immigrated to the United States, she brought along a suitcase filled with her deshilado. She sold most of it before she left the Customs House!

Once settled in Arizona, Sylvia Miranda did very little deshilado for many years. She resumed her hobby when she received an invitation to demonstrate her skills at the Tucson Meet Yourself folklife festival in the 1980s. She soon discovered that her work had a ready market, and she became quite

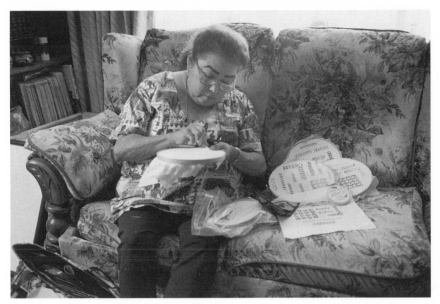

3 Antonia Aguilar working on deshilado in her living room. Finished samplers lie on the sofa beside her. Photograph by José Galvez.

active, making new pieces and teaching some of her friends her techniques. By 1996, she had to give up the craft because her eyesight no longer permitted her to follow this exacting art form.

Deshilado designs often come with traditional names attached. One of Ms. Miranda's favorite patterns is a combined wreath and cross, which she learned as Jesús *y corona* (Jesus and crown). A small, raised lozenge with three short lines radiating from one end (fig. 4) bears the colorful name *pata de garrapata* (tick's foot!). Among Toni Aguilar's mother's stitches were *ojo de rana* (frog's eye), *ojo de sapo* (toad's eye), *Jesucita,* and *flor de lis* (lily of the valley).[2]

Other forms of handwork are popular among Tucson's Mexican American women: quilting, crocheting, and embroidery using such stitches as the *punto de anís* (anise stitch) and punto de *estrella* (star stitch). Deshilado is considered by many to be the most strikingly and traditionally Mexican of these handcrafts, and it seems to be the skill most valued within the community. Nevertheless, the most commonly done handwork is crocheting. Although it is easy to focus on individual deshilado workers because there are

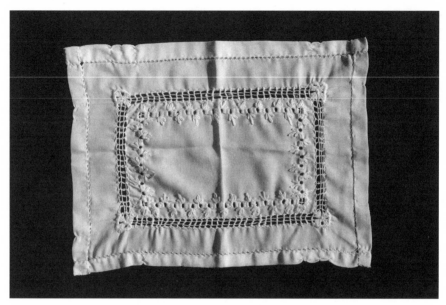

4 Deshilado napkin made in the 1980s by Sylvia Miranda. The three-lobed design is called "pata de garapata"—"tick's foot." Photograph by David Burckhalter.

few of them, the community seems full of women who do excellent crochet work.

The community also contains some remarkable seamstresses. When young women need costumes for ballet *folklórico* or the women's *escaramuza* drill team in *charro* competitions, such artists can turn out excellent work with a minimum of patterns. There are even women in the community who can look at a photograph of a wedding dress in a fashion magazine and produce an excellent copy of the dress with no printed pattern whatsoever to follow. As we examine the traditional arts of Tucson's Mexican American community, over and over we find the artists creating products that may not look "Mexican" in any way. The pattern, however, of creating items by hand to fill the needs of family and friends seems to be important within the Mexicano community, as does the emphasis on meticulous craftsmanship.

Home Altars

Catholic homes need the protection of God, the Holy Family, and the saints, and devout Catholics feel the need to be in daily communication through

prayer with at least some of these holy personages. These needs are often symbolized and filled through the arrangement and ornamentation of a home altar, or *altarcito*. Some altarcitos are permanent, such as that in the home of Ramona Benítez Franco. Mrs. Franco was born on a ranch east of Tucson near the Rincon Mountains in 1902, and her family moved to town in 1917. Her family has had a special devotion to Our Lady of Guadalupe since at least the days of her paternal grandfather, who gave his son an image of the *Virgen morena* about the time of his marriage in 1880. The image currently on her altar dates to 1895.

When she was a child, Mrs. Franco's family would honor the Virgin of Guadalupe with a feast in early December. The family would erect a *ramada,* or bower, hang it with sheets, and then decorate it with Christmas decorations and *banderolas,* or small cut-paper banners. The altar was decorated with flowers that her sister would grow especially for that purpose, and with handmade paper flowers. All the local rancheros would show up, and everyone would bring something to put on the altar. Her father would butcher a cow, and the family would prepare *carne asada*, enchiladas, *menudo*, and tamales. Everyone would stay up all night singing and praying to the Virgen. Mrs. Franco especially remembers that even the small children would be quiet and well-behaved while the Rosary was being said.

Mrs. Franco's current home altar isn't just for the Virgen de Guadalupe; it is filled with holy pictures and statues. There is an image of the Holy Child of Atocha, a specifically Mexican devotion to the infant Jesus, centered around the old silver-mining town of Plateros, Zacatecas.[3] Other figures on the altar are San Ramón,[4] the Virgin of Montserrat,[5] San Rafael,[6] and San Antonio.[7] Mrs. Franco daily addresses these and other sacred personages in prayer. Now that failing eyesight no longer permits her to read the printed prayers she prefers to use, she recites them from memory.

Not all altars are permanent. Some families erect a special altar for Our Lady of Guadalupe in early December. In such a case, the altar is often the focus for a Rosary or some other devotional exercise on the eve of December 12, the day the Virgin is believed to have appeared for the last time to Juan Diego at Tepeyac, outside Mexico City. Because Juan Diego gathered roses on the desert hill to carry to the Bishop in his *tilma* (cape), Guadalupe altars

are traditionally decorated with red roses. I have seen one that was flanked by six-foot-tall cardboard saguaros, in the arms of which doves were perched. The altar erected each year by Alicia Alvarado and members of her family is centered around a three-foot statue of the Virgin, which Mrs. Alvarado's late husband acquired at the Basilica of Our Lady of Guadalupe in Mexico City. It often features artificial flowers and cactus, a small mirror "lake," tiny statues of deer and other animals, and strings of colored lights, all assembled to create a complex whole that is truly dazzling in its impact.

Nor are all altars completely devoted to representations of supernatural beings. Family portraits can find their way onto an altarcito, serving as reminders of whom to pray for, whom to keep in one's thoughts (fig. 5). Living rooms, or *salas,* often have an entire wall set aside for such portraits, bringing the generations together, uniting those now living with those who have passed on.

It helps one to understand *nacimientos,* or Mexican nativity scenes, if one realizes that they, too, are specialized altars. In truly traditional homes, the nacimiento is the focus of devotion and prayer, just like any other altar. The use of the nacimiento may be limited to the household or may extend beyond it to a network of family and friends. The full Mexican Christmas tradition, now greatly abbreviated in most cases, might involve a pre-Christmas visit to the nacimiento by a *las posadas*[8] procession, prayers and singing to the infant Christ early Christmas morning, a celebration on *el Día de los Reyes* or the Day of the Three Kings (January 6),[9] and a final celebration on *el Día de la Candelaria* or Candlemas (February 2).[10]

At the Día de los Reyes fiesta on January 6, each guest is given a slice of *la rosca de los Reyes*—a ring-shaped cake into which are baked one or more tiny plastic babies. Those who find a baby in their slice of cake are responsible for providing new clothes for the infant Jesus, and for arranging the Candlemas fiesta in February. At this occasion, which commemorates the presentation of Jesus at the temple in Jerusalem, the newly dressed Holy Child is passed around on a platter filled with candy. Each guest kisses the Baby and takes a candy.

When María Luisa Tena was a girl growing up in Guadalajara, Jalisco, her mother had a remarkable nacimiento. It took up one room of the house,

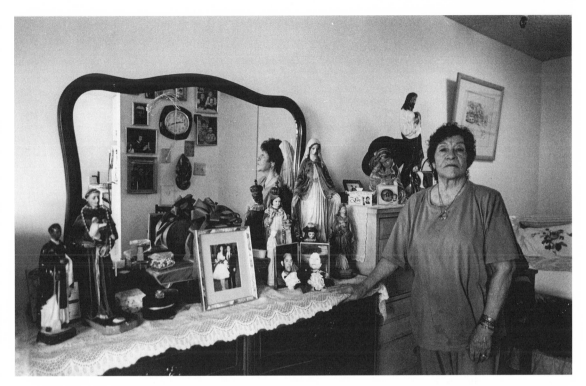

5 Soledad Osuna Marmion beside her home altar. Many older Mexican American women create and maintain home altars like this one, in which religious and family images are combined. Photograph by José Galvez.

and while it was up, her father would have his meals brought to a small table in front of it so that he could watch it while he ate. Busses would stop in the middle of the night, she remembers, just to see her mother's nacimiento! Her mother would always get up and open the house to the pilgrims. When Ms. Tena came to Tucson, she decided she wanted to honor the memory of her mother by creating a public nacimiento. The site she chose was la Casa Cordoba, a restored mid-nineteenth-century Mexican home next door to the Tucson Museum of Art in downtown Tucson. Since 1978, María Luisa's nacimiento has been a part of Tucson's public holiday tradition.

María Luisa Tena's display at la Casa Cordoba fills three quarters of a medium-sized room, starting near the ceiling and sloping gently down toward a point about two feet above the floor. At the upper right is the manger,

complete with the Holy Family, angels, and adoring shepherds. The Three Kings are glimpsed at two stages of their journey. A stream of real water runs down the center of the scene. A Mexican market and a southwestern-style Indian pueblo add atmosphere. Biblical scenes, some of which are not directly connected to the Christmas narrative, take up much of the rest of the space. There is the flight into Egypt and the massacre of the innocents, with King Herod looking on. There is the Holy Family at home, with Joseph working in his carpenter shop. There is the baptism of Christ in the River Jordan, and Jesus meeting the woman at the well. The whole assemblage is dotted with tiny, flickering lights. And María Luisa Tena insists that this nacimiento is small compared with the ones her mother used to create!

The nacimiento illustrated in these pages was inspired by Sra. Tena's work. Aurelia Araneta helped María Luisa in the early years of her project and was inspired to construct a nacimiento in her own home near the University of Arizona. The nacimiento she made for the La Cadena exhibition was simply her home display, transferred to a new site. It occupied a seven-foot-by-seven-foot corner and was seven feet at its apex. Illuminated by 1,500 tiny lights, it contained the Nativity, the adoration of the shepherds, the journey of the Magi, the flight into Egypt, the Holy Family at home, Jesus with the Samaritan woman at the well, the apparition of the Virgin of Guadalupe to Juan Diego, a Mexican market, two different stores, and a ranch scene complete with a shrine to the Virgin.

One way in which to experience a range of nacimientos in Tucson is to go on the annual Nacimiento Tour, put on every December as a benefit for the Saint Elizabeth of Hungary Clinic. An increasing number of Mexican American and other families open their homes on this Sunday afternoon. Some of the nacimientos on view consist of sets of matching figures, while others are assembled from individual figures, as is Ms. Tena's. It was in the context of this tour that I first visited the home of María de Jesús Robles.

Ms. Robles is originally from the state of Nayarit, Mexico. An active artist and craftswoman, she for many years supplied the banderolas, or cut-paper banners, that adorn Saint Augustine's Cathedral on feast days. For years she would erect her nacimiento at Christmastime and take it down for the rest of the year; in the late 1980s she decided to leave it up as an altar all

year round. It sits in her living room on a long, low table, a complex arrange-
ment of Biblical scenes and vignettes from traditional Mexican daily life.
Nacimientos such as these seem to state that the event they celebrate—the
birth of Jesus—is appropriate for all times and all places.[11]

Foods and Feasting

The mention of Mexican Christmas customs instantly calls to mind the
traditional Mexican Christmas food, tamales. Tamales—steamed dough and
filling, wrapped in corn husks—originated in pre-Hispanic Mexico. Then, as
now, they were a food made for special occasions. At Christmastime, Mexi-
can American families make tamales filled with meat—beef, pork, or game of
some sort—cooked in a red chile sauce.[12]

The making of the tamales is an occasion for family members to get
together and work cooperatively, for tamales lend themselves to a sort of
assembly-line approach. Such a tamal-making event is called a *tamalada,*
and attending tamaladas is often considered a familial obligation. Many things
occur at a tamalada in addition to making tamales: family problems are dis-
cussed and perhaps sorted out; everyone gets a chance to hear and evaluate
the latest news and gossip; and the family is made a little stronger, a little
more cohesive, as the women prepare the *masa* (corn-flour dough), prepare
the meat for the filling, and fill and wrap the tamales themselves. Tamales are
typically made in huge quantities. It is not unusual to hear of a family turning
out 100 dozen or more tamales for the holidays. This becomes understand-
able when one realizes that not only are the tamales consumed in vast quan-
tities on Christmas day by members of the extended family, they are often
given away in lots of at least a dozen to a circle of family friends.

Christmas tamales are a perfect example of folk art. The nature of ta-
males, like their making, is governed by a strong, widely understood set of
cultural rules and aesthetic codes. In southern Arizona, Christmas tamales
are all made to the same general pattern. Masa or dough is made from ground
corn that has been treated by soaking it in lime, a process that goes by the
wonderful name of "nixtamalization," from the Aztec word for the end prod-
uct, *nixtamal.* To the masa are added some lard, or other shortening, and red
chile sauce. This masa is then smeared on a prepared corn husk, and a meat-

and-red-chile filling is added before the tamal is wrapped. One end is folded over, to keep the contents from spilling out, and then the tamales are stacked vertically in a pot and steamed. That's it. Although tamales are made in other parts of Mexico with banana leaves, or with corn husks that are tied at both ends, or with fillings of pork, chicken, or some other meat, and although tamales of fresh, white corn (tamales de *elote* or green-corn tamales) are made in Tucson in the summer, they are not typically made thus in Tucson at Christmastime.

But within this general pattern, the possibilities for individual family recipes are endless: variation in the precise proportions of the ingredients for the masa; variation in the meat and chile filling; variation in whether an olive is added to the filling, and if so, what sort of olive. No two families make identical tamales, which adds to the pleasure of receiving tamales as a gift. They are bound to be slightly different from one's own.

As I said, tamales are made in infinite varieties all over the Mexican world. But some dishes are considered to belong specifically to Tucson and the Pimería Alta. Many of these involve wheat and beef, two staples introduced in the late seventeenth century by Father Kino and other Jesuit missionaries. Prominent among these is the huge regional flour tortilla—the tortilla *grande de harina* or tortilla *de jalón* (pulled tortilla). Made of wheat flour, water, lard, and salt, these huge tortillas are traditionally made only in the Sonoran Desert region of Arizona and Sonora. They can measure as much as thirty inches in diameter. Other tortillas are made regionally as well—flour *gorditas* (little fat ones) with milk in them, whole wheat tortillas, and the ubiquitous corn tortillas—but the tortillas grandes stand out as regional specialties.

Beef and cheese play a major role in the local diet. *Carne de chile colorado,* or beef with red chile, is a long-time regional staple. This dish can be very spicy indeed, and it is mentioned in Jesuit missionary Ignaz Pfefferkorn's 1794 book on Sonora as something he first encountered in this region: "After the first mouthful the tears started to come. I could not say a word and believed I had hell-fire in my mouth."[13] It remains an important regional feast dish. Beef cooked over an open fire—carne asada—is also considered typical regional food and is now a picnic specialty, reminding many of the days when southern Arizona was covered with Mexican-owned *ranchitos,* and it was possible to eat one's own beef.

Beef is also seasoned and dried to make *carne seca,* an important staple. When carne seca is pounded into shreds, it becomes *machaca.* Machaca will keep forever without refrigeration; it is often cooked with onion, garlic, tomato, and green chile and served either by itself or with scrambled eggs. It also serves as the basis for the traditional *cazuela,* a soup that can also contain onions, tomatoes, ears of corn, green chiles, and other vegetables.

Another legacy from cattle-raising days is cheese. Cheese is included in a multitude of dishes; it can be melted on top of tortillas or combined in broth with green chiles and potatoes to make cheese soup, *caldo de queso,* a favorite Lenten dish. A final specialty of the region is enchiladas *chatas,* or flat enchiladas. Flat cakes of masa are mixed with red chile and cheese and fried. They are usually served covered with more cheese and a red chile sauce.

All these are true regional folk dishes. They exist in infinite variety among the region's households and are usually prepared, not from written recipes, but from learned family tradition. Such dishes may be less common than they were a generation ago, but they still form a kind of basic repertoire for Tucson's Mexican American family cooks.

Cooking is the domain of the women in traditional Mexican American culture. However, there is one exception to this rule—outdoor cooking, which is men's work. This includes barbecuing over an open fire as well as in a pit. For open-pit cooking, men sometimes make portable barbecue "pits" from fifty-gallon drums cut in half lengthwise. Legs made of steel angle irons and handles at each end complete the cooking pit. If the maker owns horses, the handles are likely as not to be made of old horseshoes.

These cookers are usually not bought and sold in stores, but rather a man will learn to do the work, make one for himself, and then supply others to family members and close friends for the cost of the materials. They become the focal points for weekend social functions in which the men gather outdoors, drink beer, and cook carne asada or *tripas de leche* (grilled marrow guts). Social events such as these are in a way the male equivalent of the tamalada.[14]

Yard Ornamentation
While enjoying themselves thus, the men may well sit on homemade benches. These are often made by men out of recycled lumber and consist of

a top, two plank legs, and side strips to stabilize the whole thing. They may then be painted (often with paint left over from some other project) and even upholstered with sample scraps from a carpet store. Like the barbecue pits, they are useful objects created out of recycled materials and are usually given away within a circle of family and friends.

Houses, of course, have exteriors as well as interiors, and Mexican Americans have a traditional style of front yard that is common to Tucson. Its first characteristic is that it is separated in some way from the street. The most common boundary marker is a chain-link fence, either three or six feet tall. This serves to create the enclosed space that is such an important part of the Mexicano townscape. Such a division is in strong contrast with the majority of mainstream yards, which serve as an unfenced neutral space between the public area of the street and sidewalk, and the house itself.[15] The oldest parts of Tucson are filled with what architectural historians call "Sonoran-style row houses"—long houses fronting right on the sidewalk, with an enclosed patio or family space within the house itself. The traditional Mexicano preference for a fenced yard—with the private space extending right to the sidewalk—seems simply to be a continuation of this older housing pattern, adapted to the requirements of modern, Anglo-dominated building regulations.

Although the most common form of fence is chain-link, about three feet high, some families prefer wrought iron fences, or even wrought iron and masonry combinations. Brick pillars can separate stretches of decorative wrought iron fencing, or in more elaborate cases, a scalloped brick or block wall may contain half-circles of wrought iron.

Within the fence, there is usually no grass lawn, but rather hard-packed, raked, or swept dirt bearing a collection of shade trees and plants, the latter often in containers. This preference for container growing may well date from an earlier time when water was drawn from a well, and it was easier to keep container plants moist and healthy than plants placed in the ground. There are few constants among the plants preferred, but one friend has mentioned geraniums as a favorite, along with mint *(yerbabuena),* which needs lots of water and is therefore often planted under a leaky faucet. Yerbabuena has traditional medicinal uses; taken in tea, it is believed to settle the diges-

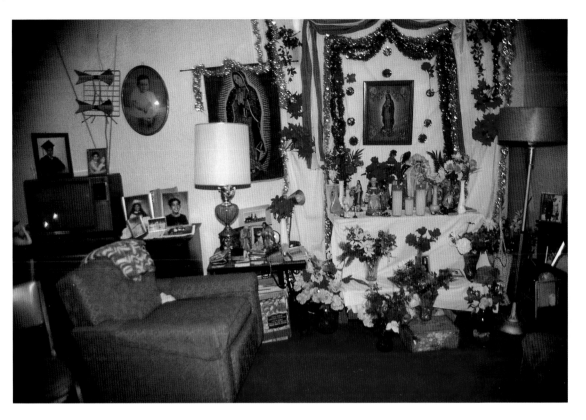

A permanent altar to the Virgin of Guadalupe, partially filling Ramona Franco's living room. This wonderful altar is in place throughout the year. Photograph by Cynthia Vidaurri.

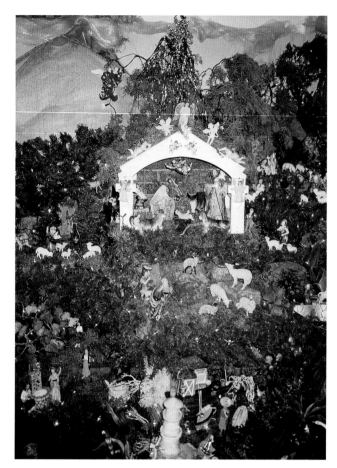

The Araneta family's nacimiento, as it appeared in their living room in 1992. The Holy Family occupies the top center of the scene, with the Adoration of the Shepherd around and below them. To the lower left is the scene of Jesus with the Samaritan woman at the well. Photograph by Jim Griffith.

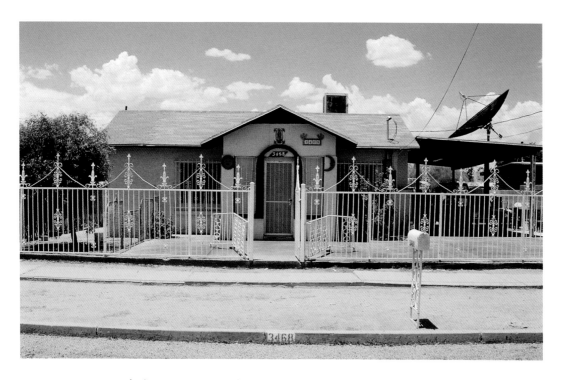

Front view of a house just south of South Tucson. Note the ornate fence at the sidewalk line, the red cement yard surface, the Virgin of Guadalupe over the front door, and the sun and moon flanking the door. Photograph by Jim Griffith.

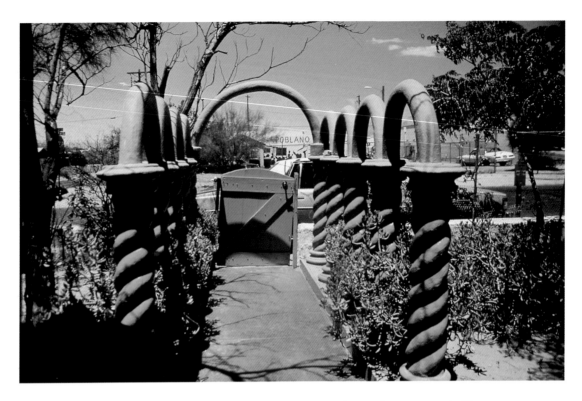

The front walk of a house just north of Speedway and east of I-10, in Barrio Blue Moon. No wonder that some local children call this "La Casa McDonald." Photograph by Cynthia Vidaurri.

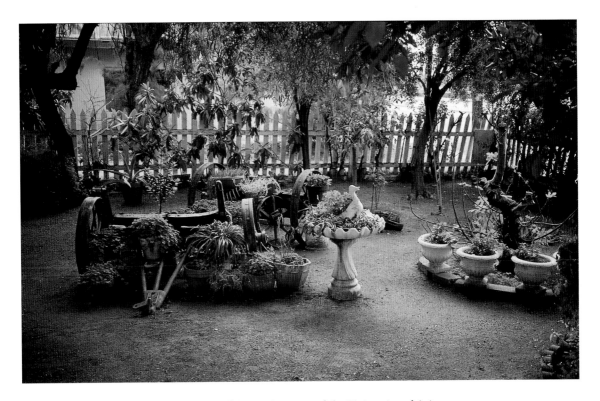

The backyard of a house on 2nd Street, just east of the University of Arizona campus. With its carefully raked dirt surface, formal arrangements of potted plants, and the wagon to make a statement of rural connections, this is a classic Mexicano backyard space. Photograph by Jim Griffith.

A nicho on South 4th Avenue. The baroque heritage shows through clearly in the use of light and color, and in the multiplicity of images and materials. Photograph by Jim Griffith.

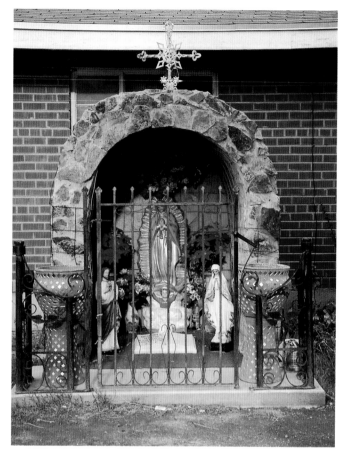

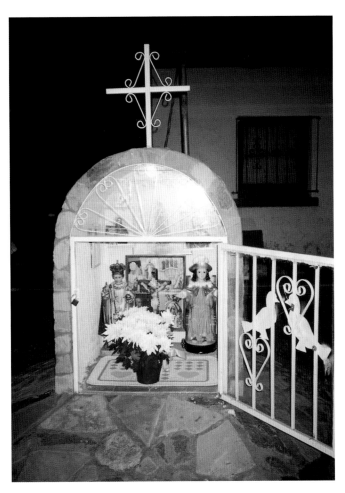

A nicho in South Tucson on the evening of its dedication. The skills of the stone mason and ironworker are combined to produce this elaborately filled nicho. Photograph by Jim Griffith.

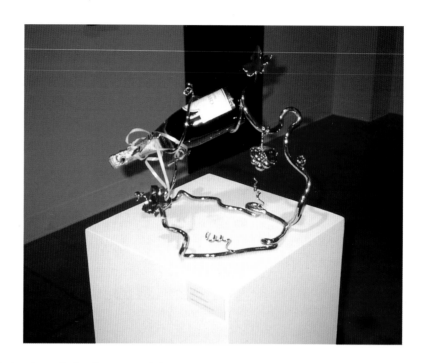

Gold-plated, single-bottle wine rack by Joe Hernández, Jr. This elaborate rack, wrought in the form of a grapevine, complete with leaves and fruit, is a classic contemporary baroque creation. Photograph by Jim Griffith.

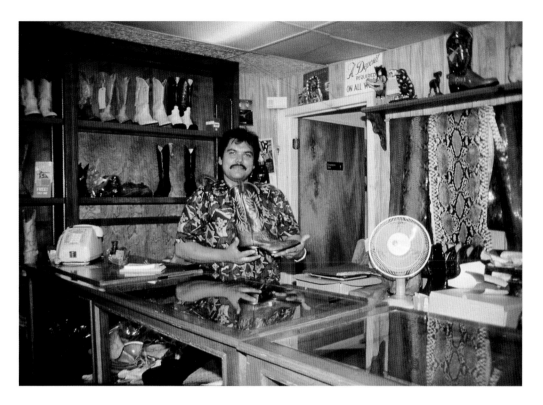

Estevan Osuna behind the counter of Osuna Boot Company on South 12th Avenue. By 1999, the store was closed. Photograph by Cynthia Vidaurri.

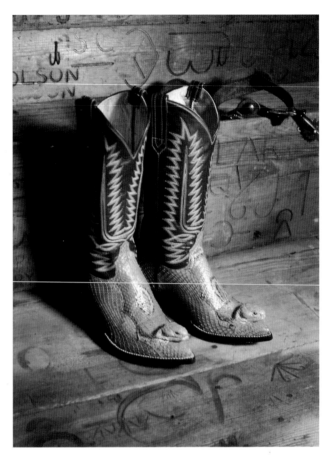

Cobra-skin boots, complete with heads, made by Claudia's Boots on South 6th Avenue. Photograph by David Burckhalter.

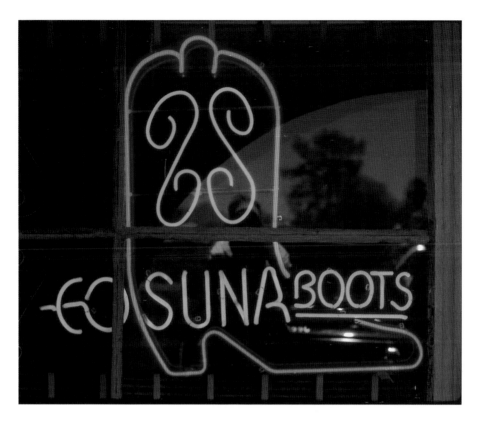

Neon sign advertising Osuna's Boots, artist unknown. The complex letter "O" in "Osuna" is the family cattle brand. Photograph by Jim Griffith.

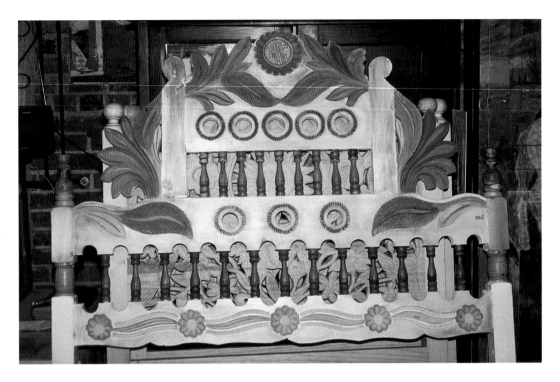

Headboard made by the Mendívil/Olmedo family craftspeople at ¡Aquí Está! on South Park Avenue. Photo by Cynthia Vidaurri.

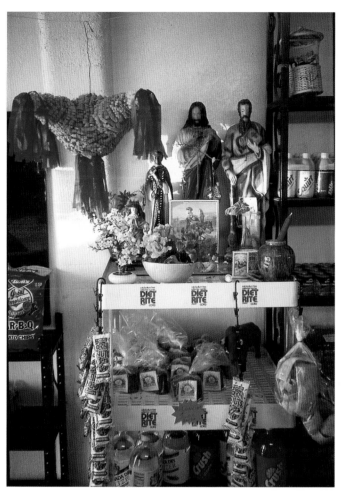

Altar in La Jaliciense candy factory and store on South 12th Avenue. The principal figures include, from left, San Martín de Porres, San Martín Caballero (patron of businesses), the Sacred Heart of Jesus, and San Judas. Photograph by Jim Griffith.

Banderolas marking the route of a religious procession. La Fiesta de San Agustín, August 1992. Photograph by Jim Griffith.

Food booth decorated with paper flowers for La Fiesta de San Agustín, on East 2nd Street, outside the Arizona Historical Society, August 1995. Photograph by Jim Griffith.

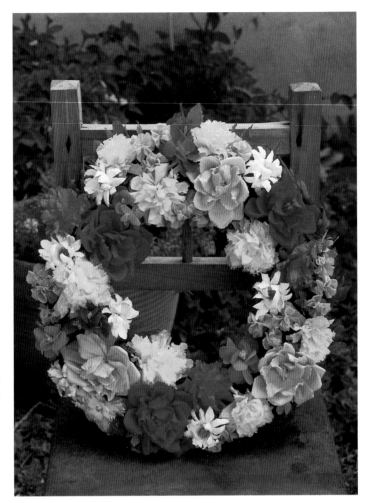

Paper flower corona made by Josefina Lizárraga, showing a variety of blossoms and techniques. Photograph by Jim Griffith.

Cascarones for sale at the Club Los Chicos booth at the Tucson Meet Yourself festival, October 1990. This style of cascarón emphasizes the paperwork rather than the treatment of the eggshell. Photograph by Jim Griffith.

"Garfield" on display by The Dukes Car Club at Southgate Shopping Center, September 1996. Photograph by Jim Griffith.

"Aqua Shock," owned by Deano and Lorinda Rowe, on display at the Low-Rider Car Show at Tucson Electric Park, November 1998. Low-rider displays can be quite elaborate, often echoing the theme of the car's decoration. The elaborate credit sign includes the name of the sign painter. Photograph by Jim Griffith.

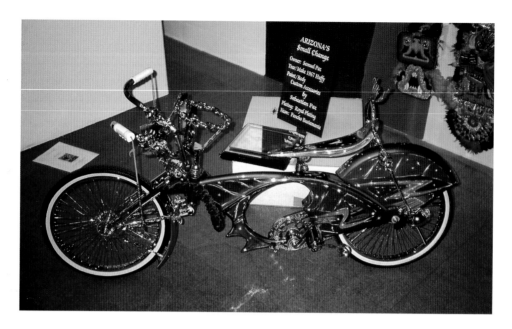

"Arizona's Small Change" low-rider bike just before being placed on display at the University of Arizona Museum of Art, November 1997. The bike is owned by Samuel Paz and customized to a great extent by his older brother Sebastian. Creating low-rider bikes has become a hobby in which the entire Paz family participates. Note the credits for every part of the process. Such credits are a standard feature of low-rider car and bike displays. Photograph by Jim Griffith.

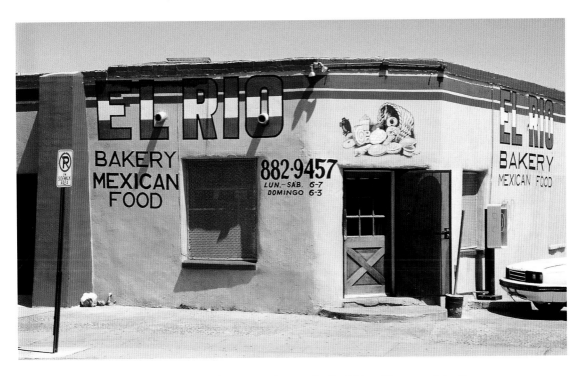

El Rio Bakery on North Grande Avenue. Signage by Paul Lira. Photograph by Jim Griffith.

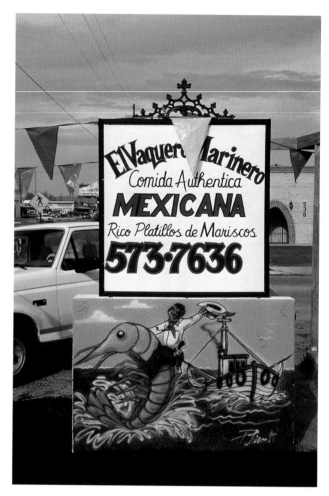

El Vaquero Marinero, a short-lived seafood restaurant on South 12th Avenue. Signage by Paul Lira. Photograph by Jim Griffith.

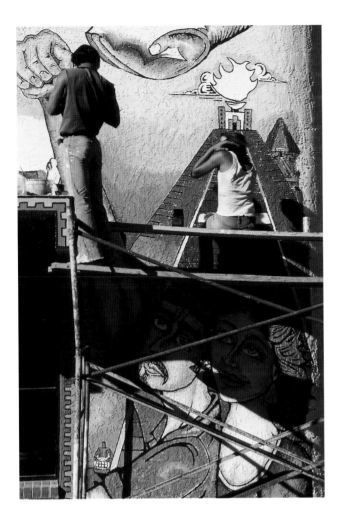

David Tineo
and an assistant
painting a mural
on the El Río
Neighborhood
Center on West
Speedway,
October 1979.
Photograph by
Jim Griffith.

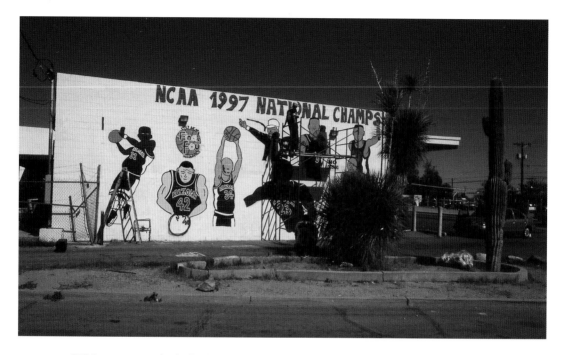

Wildcat NCAA Basketball Championship mural on the Holiday Mart on West 22nd Street. Ismael Galindo is at work with two of his friends, April 1997. Photograph by Jim Griffith.

tive system. Many of the plants traditionally grown in Mexican American gardens have medicinal or culinary uses as well. Among the plants commonly found growing in the ground rather than in containers are roses, lantana, and aloe vera.

Even the smallest yards may be quite formally laid out. Trees and shrubs may be set off by borders, often consisting of plain or white-painted stones. I remember visiting a yard in which a chinaberry tree was set in a raised circle of earth. This circle was bordered by a palisade of dark brown, quart-size beer bottles with the labels removed, carefully set upside down, with their necks buried in the dirt. The result was a softly shining border, solid-looking but reflecting the light and movement around it.

The containers that appear in traditional Mexican American yards are often recycled. In many cases, this does not appear to be simply a matter of thrift. Many of the containers may be retained from the houses of parents or deceased family members, or are mementos of friends. Thus, one friend of mine plants flowers in an old pitcher that belonged to her mother-in-law, uses the base of her mother's worn-out wood stove for a table to hold other pots, and keeps her father-in-law's water bottle hanging from a tree, fifteen years after his death, among a host of other recycled containers. Almost every object in her yard has its story, and most stories are connected with specific, fondly remembered individuals. Such a yard becomes a kind of physical map of an intricate series of kinship ties and social relationships—a chart of a society. Working or resting there, one is surrounded by reminders of friends and family just as surely as one is in one's living room with its groups of family portraits.[16]

While some Mexicano yards may be rather sparsely occupied, with neat, white-painted borders around trees and bushes, and tight clusters of planters and containers, others may be extremely complex assemblages that include plants, containers, holy statues, and recycled materials of various kinds, all presented in a positive riot of detail. Such yards continually remind the viewer of the strong debt that traditional Mexican American aesthetics owes to the baroque decorative style of the eighteenth century, with its wealth of detail, its contrasting plain and densely-decorated surfaces, and its emphasis on color, richness, movement, and drama.

Yards may also contain religious shrines, or *nichitos* (fig. 6). A shrine will often be erected by a family member as a result of having prayers answered—prayers for the recovery of health or for the successful resolution of some other family crisis. The helpful saint or a member of the Holy Family will be honored by being placed out in full view of the street, in a separate architectural setting. Almost inevitably, the shrine will be lit with one or more electric lights.[17]

These nichos can be of almost any shape, but the most common is an arched niche made of cast cement or occasionally of brick. But here again, custom permits almost infinite variation. One shrine on Tucson's south side, since removed, consisted of a miniature baroque church, complete with bell towers. Strings of artificial holly, tiny white lights, and silver bells hung across

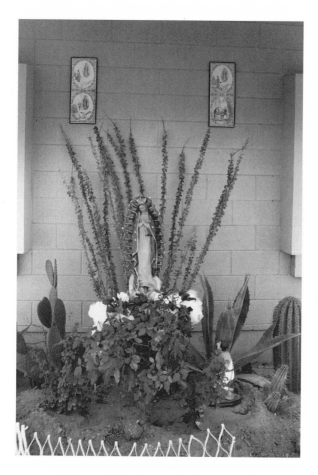

6

Shrine to the Virgin of Guadalupe outside an apartment in the Connie Chambers Housing Projects on South 10th Avenue. This elaborate shrine was created by the resident of the apartment directly behind it, and was removed when the Projects were demolished in the late 1990s. It became a place where neighborhood women would come on a regular basis to pray the Rosary. Photograph by Jim Griffith.

the facade. Within stood a statue of the Virgin of San Juan de los Lagos, an extremely popular devotion from the state of Jalisco.[18]

Sometimes the shrine itself may be recycled from something else. A shrine to Saint Dymphna used to stand in a front yard in the tiny barrio just to the southwest of the Tucson Convention Center. It was made from an old bar-sized refrigerator. An extension cord from the house brought power to the icebox light. A reclining statue of Saint Francis Xavier occupied the freezer compartment.[19]

Once a shrine is established in a front yard, neighbors with a strong devotion to that particular saint may well come by occasionally to pray in front of the shrine. In this way, the shrine becomes a public site for prayer as well as a private statement of faith and obligation. Occasionally, such a shrine may grow in importance until it almost outgrows the yard it is in. Such are the shrines to Saint Jude, on South 8th Avenue, and to El Señor de los Milagros, on North Melwood. Each shrine is the site of an annual Mass performed by a local priest; each is a place where neighborhood people and others from farther away come to pray for miracles. Each has kneelers and benches and a collection box. The shrine to El Señor de los Milagros, in particular, has attracted the addition of other statues and a large number of *milagros*— those tiny metal representations of body parts, animals, and even inanimate objects that serve both as symbols of petition and as offerings of thanks.[20]

It is fitting that this discussion of the traditional arts of the home—el hogar—begins and ends with images of the Catholic faith. Although many Mexican Americans have indeed joined churches other than that of Rome, for many more, identity as a Catholic is inseparable from identity as a Mexicano or Mexicana. It is as central to that identity as the altarcito is to the household, and it is still as much a part of the community's projected image as the yard shrine is a part of the home's projected image.

El Taller/The Workshop

If the home is the woman's domain, then *el taller*—the workshop—belongs to the men. It is men who traditionally work outside the home to earn the money that supports the family, and although this traditional division of tasks within the family is changing, its effects are still important within the Mexican American community. Traditional commercial crafts still support many families in Mexican American Tucson.

Ironwork

The oldest known pieces of decorative forged iron near Tucson are two crosses, one on the main dome and one on the completed west tower of San Xavier Mission.[21] Each is a simple Latin cross to which have been added pieces of curved iron to produce an elaborate filigree effect. Each was made, so far as we can tell, in the late eighteenth century. Each, though highly ornamental, is in fact functional in several senses. One function is social: The cross, symbol of the Christian faith, states clearly that the building on which it stands is a church. Another function is purely physical: Each cross serves as a highly efficient lightning rod. A third function, no less important, is spiritual in nature: The cross serves as a protection against the forces of evil that threaten the devout Christian in every context he or she might be in.

Iron is still worked by Mexicanos in the Tucson area. Thirteen of the twenty-four family names attached to ornamental metal companies in the 1995 Tucson Yellow Pages were Hispanic. And the same decorative elements that appear on the crosses of San Xavier—S and C curves for the most part—appear on the burglar bars and iron doors that are among the mainstays of contemporary ironworking (fig. 7). A glance at the Yellow Pages reveals that most of the shops taking out advertisements describe themselves as producing such highly functional items as security doors, window guards, and pool and patio enclosures. The pictures accompanying the ads, however, show these functional objects in highly decorated forms.

Ortiz Wrought Iron, Inc., on Irvington Road, is one such company. Its owner, Juan M. Ortiz, originally came from Tepache, Sonora, near the capital city of Hermosillo. Mr. Ortiz has several men working for him in the

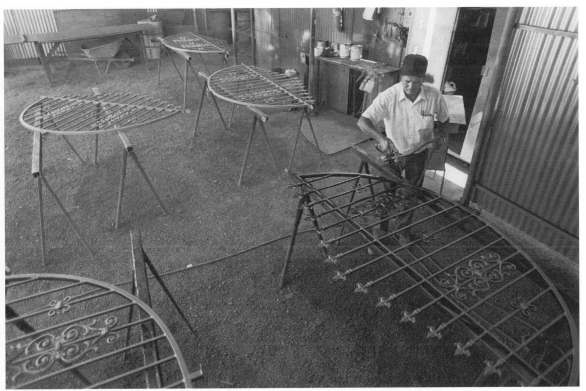

7 Working on ornamental gratings at the Ortiz Wrought Iron workshop. The decorative elements are precast and then added to the grating. Photograph by José Galvez.

shop, producing work to order. In addition to their "bread and butter" burglar bars for windows and doors, the Ortiz shop has produced special custom work, including decorative iron chairs and tables, and even a huge steel counter for a Tucson hairdressing establishment. In 1996, the company limited itself to the more standard items such as burglar bars and fences.

William Flores is Tucson's oldest working blacksmith. His shop on North Main Street has a look of great antiquity and, in fact, has been a local fixture for years. One sign of how long the shop has been there is a wooden panel behind a work table near the forge. Into the panel are burned the brands that Mr. Flores has made over the years for ranchers in the area—a once common sight in western smithies, but now getting rarer each year. The Flores shop

turns out ornamental door handles, door knockers, fire tools, lamps, and candle holders. Many are in an elaborately floral style.

Joe Hernández, Sr., went to welding school when he got out of the Navy and became a welding electrician. He bought his first welding machine in 1971. One thing led to another, and he started making functional items and slowly acquiring tools. He began working with iron, joined the Arizona Artist Blacksmiths Association, and started going to the workshops sponsored by that organization. By the time he was ready to retire, he was also ready to go into full-time blacksmithing. Now, he says, he gets to work at what he likes to do (fig. 8).

His Adobe Anvil Smithy operates in the garage of the home that he built for himself and his family on Tucson's northwest side. (Joe's mother-in-law is Mary Venuti, well-known and greatly loved within her community as a traditional musician.) There, he and his son (who also has a full-time job)

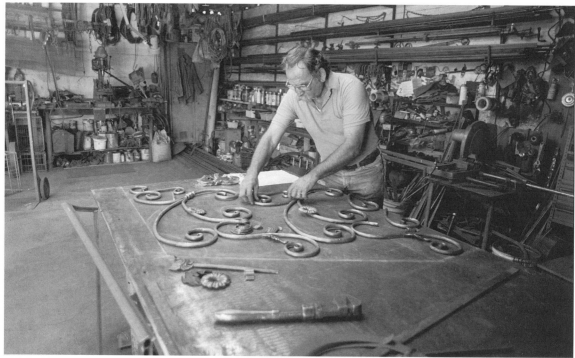

8 Joe Hernández, Sr., assembling a wrought iron piece in his smithy. Photograph by José Galvez.

fill their orders and experiment with various ideas. Joe has made candelabra, pot-hangers, fireplace sets, a few doors, and other decorative pieces such as roses. Joe Junior makes spurs on his own, as well as innumerable variations of human and animal figurines using horseshoes as a basic component. The Hernándezes often put up booths and demonstrate their skills at such public events as the Tumacacori Fiesta and the 4th Avenue Street Fair.[22] Joe Senior likes to visit other smiths and learn from them. A fifth-generation Tucsonan, he works solidly within the general tradition of baroque ironwork that reaches back in this community through Raúl Vásquez to the anonymous creators of the crosses at San Xavier Mission.[23]

Leatherwork

Osuna Boots has its store and workshop on South 12th Avenue, behind an outer, ironwork door created by a local ironworker.[24] Inset into the vertical iron bars of the door is the outline of a boot, created from a motorcycle chain. Two curved upright pieces suggest the stitching patterns of the boot top. Below is the brand of the Osuna family's ranch near Tubutama, Sonora— the letter "O" in combination with an arrow. An older generation of the Osuna family made boots for several years near Caborca, Sonora. Estevan Osuna moved from Tubutama to Tucson at the age of four. The work tasks in the Osuna shop are highly specialized. Nobody makes an entire pair of boots, but rather each worker is a specialist. The *zapatero* (shoemaker) makes the boot and puts on the heel. The *pespuntiador* does the machine stitching, while the *acabador* does the finishing work.

This tradition of specialization within a workshop goes back a long way in Mexico. For instance, the typical eighteenth-century baroque religious statue was made by a team consisting of a wood carver, a specialist to clothe the statue in gesso and cloth, yet another man to apply the flesh tones, and a final artist whose job was to decorate the garments with patterns of tooled gold leaf. Such colonial craftsmen would find themselves on familiar ground with the division of labor, if not the machines, in the Osuna shop.

The Osuna boots are made for a mostly Mexicano clientele and reflect what is popular within that community. Special leathers such as snake, shark, eel, and anteater are mentioned as being popular in the 1990s. Ostrich is the

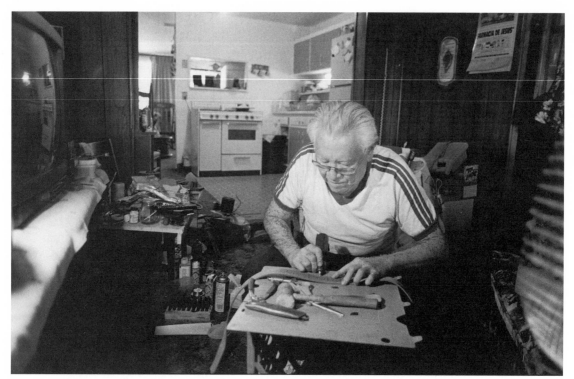

9 The late Henry "Bambi" Gómez doing leatherwork in his home workshop. Photograph by José Galvez.

most popular. Fashionable boots can be very brightly colored, and Mr. Osuna has made purple and pink boots for men. The top of the boot *(el cañon)* can have stitching of any degree of fanciness, or leather inlays. Some customers request their brands on their boots.

Claudia's Boots on South 6th Avenue also caters to a high percentage of Mexicano customers. Luis Maldonado, who works at Claudia's, says that two principal styles of heels sell in Tucson. One is the "roper," a flat walking heel popular all over the West. The other, the highly regional "Sonorense" or Sonoran-style heel, is sharply undercut and is a favorite of vaqueros from across "the line." The Maldonado family boots, like those made in the Osuna shop, emphasize brilliant colors and exotic leathers. One popular specialty of Claudia's is a boot made from cobra skin, complete with the cobra's head, set with tiny red glass eyes, on the toe of each boot.

Claudia's also makes belts. As with boot heels, there are two popular

styles. The "vaquero" is one-and-a-half inch wide, whereas the "ranger" is narrower. Mexicanos prefer the wider belts, which, in Mr. Maldonado's words, *lucen más* (show off better). Some customers prefer to have their belts made of hides that match their custom-made boots. These special leather belts, which are preferred by Sonorans, present a contrast to the tooled, personalized cowhide belts popular among Mexican Americans in the Tucson area.[25] People desiring tooled belts might be more likely to patronize a local craftsman such as the late Henry Gómez (fig. 9).

Henry "Bambi" Gómez learned to work leather when he was in the Veterans Hospital with a serious lung illness (which he eventually cured with traditional herbs). He worked leather for more than fifty years, serving the community out of his house (fig. 10). He made belts, wallets, holsters, photo album covers, and a host of other standard and unusual items, mostly for

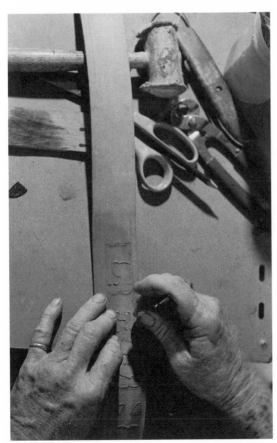

10

A detail of the late Henry "Bambi" Gómez's leatherwork. Photograph by José Galvez.

members of Tucson's Mexican American community. Among his more unusual pieces were automobile dashboard covers and a leather vest for a dog belonging to a New York pet shop owner. For one customer he made a black leather saddle with silver *conchos* (buttons) and a matching leather hat, bolo tie, watch fob, vest, and boot embellishments. He made a presentation album cover for Pueblo High football coach Lou Farber and matching belts for the famous rock group the Rolling Stones.

Mr. Gómez (he got the nickname "Bambi" from his running skills in football) worked alone, out of his house. He was known all through Tucson's southwest side as a leather worker. It is difficult to know exactly in which of the contexts used in this book (that is, hogar, taller, or comunidad) to place Mr. Gómez. He worked out of his home, he served a specific southside and westside Mexicano community, and he pursued a commercial craft tradition. This is a recurrent dilemma that serves as a reminder that in dealing with cultures, hard and fast rules frequently do not apply.

Neon

Juan de la Cruz was raised in Nogales, Sonora. Although several of his family members were carpenters, Juan wanted to try something different. After completing the equivalent of junior high, Juan was sent to work in a neon-bending shop belonging to his brother-in-law. While doing the maintenance work and cleaning that his job entailed, Juan watched the glassblower at work and decided that this was what he wanted to do for a living. He worked with his maestro, Alejandro Campa, until he was ready to do the work himself. After working for several companies in Nogales, he decided to come to the United States in the early 1960s.

Juan started off in Tucson working for others, but decided to go into business for himself in 1980. He worked out of his home until he had established himself and could afford a storefront operation. His company, DeLaCruz Neon Signs, is on North Stone Avenue. He works to order, designing and making whatever his customers want (fig. 11).

A blue neon crucifix, a pun on his name, stood in his window for many years until he gave it to his mother. One of the most complex jobs he has done was to create a neon Virgin of Guadalupe (Guadalupana) for a film

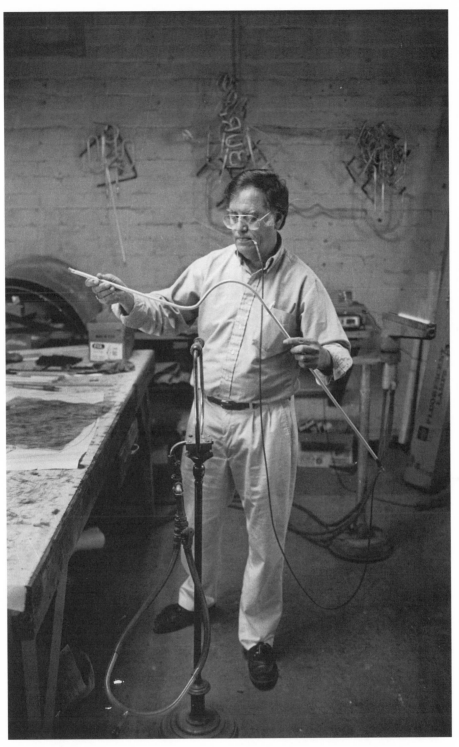

11 Juan de la Cruz bending neon in his workshop. Photograph by José Galvez.

company, to be used on location in Guatemala. He later made another for the film's director, who has it in his home in Hollywood. A third and final Guadalupana was made specifically for the La Cadena exhibition. These images stand about thirty-six inches tall and took two or three days to make, working part-time. More movie work came when Juan reproduced a street in 1950s Las Vegas for the movie *Desert Bloom*. This job took him two-and-a-half months to complete.

Juan de la Cruz starts off by sketching the design on paper, then enlarging it to the required size. (Exact size is an important consideration in getting a City of Tucson permit, which is an essential step in erecting any sort of outdoor sign.) He then follows this template with the neon, bending the glass where needed, and trying to keep all the bends invisible at the back of the sign. He also does neon sculptures and has created flamingos, cacti, stars, and dragons, among other images.[26]

Designing and making neon signs and sculptures requires a lot of skill and practice to do it correctly. Mr. de la Cruz practiced for seven months when he made his first sign. After all these years of working neon (since the age of fifteen), he still finds the work satisfying and stimulating.

Woodwork

Several furniture- and door-making shops in Tucson are operated by Mexicanos. Among these is La Colonia Furniture on South 4th Avenue. Armando Rodriguez, owner of La Colonia, was born in Nogales, Sonora. He picked up his skills by watching others, while supporting himself in another job. He eventually quit his other job and turned what was a hobby into a full-time occupation. He will make anything to order that can be made from wood: beds, tables, dining room sets, doors—anything. He works with both pine and mahogany. The other carvers he works with prefer mahogany, while he prefers pine. A cabinet will take about a week if he works full-time on it, but one of the great advantages of carpentry is that one works when one feels like it. In his spare time, Rodriguez plays *tololoche* (stand-up bass) in a *norteño* band with one of his carvers and two other men, one of whom is also a carpenter. They play in their spare time and on weekends.

Alejandro Gómez occasionally helps out at La Colonia as a woodcarver.

He is from Guadalajara, Jalisco. He started working as a carpenter at the age of twelve and became a *tallista en madera,* or woodcarver, at eighteen. He came to the United States in 1962. Before immigrating, he did a lot of carving for churches in Mexico, along with his maestro, Amado Magana. He continued some of this religious carving here in Tucson. One of his most visible pieces is the large *tablero,* or panel, of Our Lady of Guadalupe on the facade of the Chapel of Our Lady of Guadalupe on 33rd Street and 3rd Avenue. In the 1970s, he was employed to make hand-carved wooden panels and pieces of furniture. Molds were made from these, and copies cast in plastic were mass-produced from the molds. With all his skill and love for the work, however, he doesn't consider himself an artist, but only a copyist—an opinion not shared by his fellow woodcarvers.

Another Tucson woodworking shop is Diana's Doors on South 6th Avenue. Ignacio Fereira Rodriguez was born in a small community near Hermosillo. He started learning to carve wood *(tallar madera)* from a carver in Nogales, Sonora, at the age of sixteen. At the same time, he was learning the more marketable skills of a carpenter. At Diana's Doors, he works mostly as a carpenter and feels that the general public doesn't want to pay for hand-carved work. Even so, he does get occasional orders for doors with hand-carved panels or tableros. Craft-based businesses can be transitory; between September 1994, when Sr. Fereira was interviewed, and September 1996, Diana's Doors went out of the door business and became Diana's Tires. By August 1998, the building once more housed a door factory.

A different kind of woodworking experience is shared by members of the Mendívil/Olmedo family. While still living in Mexico, Marta Mendívil, the mother, started taking art classes. Soon, enough family members were enrolled that they made up a class by themselves. After moving to Tucson, the family started putting their artistic talents to use as a means of earning a living. Starting off with an import store, they moved into the business of furniture production, and now much of what they sell in their store, ¡Aquí Está! on South Park Avenue, is of their own making (fig. 12).

One of Marta's sons by a previous marriage, Gerardo Olmedo, is the *carpintero* and woodcarver. His brother Carlos Olmedo finishes the furniture in the Mexican style, the *terminado* Mexicano. Mother Marta and daugh-

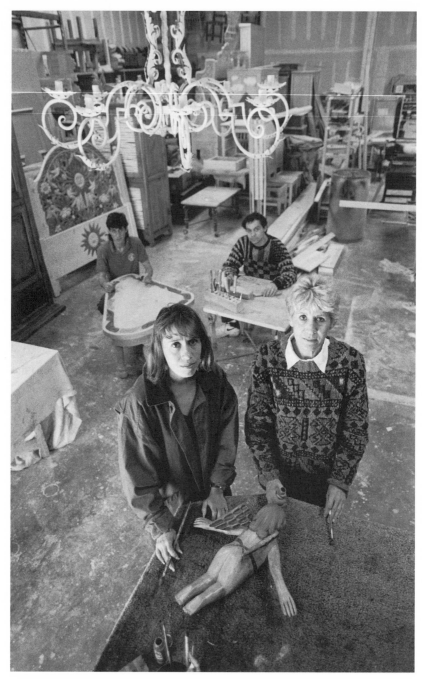

12 The furniture makers of ¡Aquí Está! Carlos Olmedo and Eduardo Olmedo (with tools) in the background; Edna Olmedo and Marta Mendívil standing. Photograph by José Galvez.

ter Edna Olmedo paint the furniture with floral and landscape designs, which are typical of the Michoacán regional style that they have adopted as their own. Unpainted furniture just doesn't sell as well as the brightly painted pieces, they have found. Señor Mendívil's daughter, Luz Marina Mendívil, handles the business end of things and creates custom designs. She is studying interior design in Tucson. Oscar Olmedo, another son, creates custom lamps out of Tarahumara Indian pottery from Chihuahua. Marta's husband, Ricardo Mendívil, does the importing for the business. Another daughter, Claudia Olmedo, owns another store, La Casa Mexicana, specializing in gifts and accessories.

Mrs. Mendívil says that Mexican-style furniture is *más elaborado*— more detailed—than its American counterpart. The Mendívils make many pieces of furniture—headboards for beds, frames for pictures and mirrors, chairs, entertainment centers, and *trasteros* or hutches—but it's the dining room sets that sell best.

Prominent in the store is Mrs. Mendívil's altar. In fact, it is so large and prominent that some visitors, myself included, took it at first for a display of materials for sale. This is not the case, however. The most prominent saint is San Martín Caballero—St. Martin of Tours—the patron of business people. Surrounding him are other pictures as well as various articles that were previously on other altars. Holy water in a small container sits on the altar, along with other meaningful objects.

Another Tucson furniture maker is Luciano Valencia Figueroa. In the mid-1990s he was working at Arroyo Design on North 4th Avenue. He learned to make furniture in Nogales, Sonora, before coming to the United States in 1985. He worked for twelve years in a Nogales shop, where they worked with many kinds of wood and made furniture in many different styles. Although he has made many styles of furniture, including Spanish colonial, his favorite is the "French" or Queen Anne style, very popular in Mexico. In his job with Arroyo Design, he works to their designs and specifications, mostly with mesquite wood. What he brings to his work as a Mexicano craftsman is his rigorous training and meticulous attention to detail (fig. 13).

He really likes working in wood, and wishes he were financially able to

build his own house and fill it with furniture of his own making. As it is, he has made a colonial-style dining room set for his own home and a bedroom set for his daughter.[27]

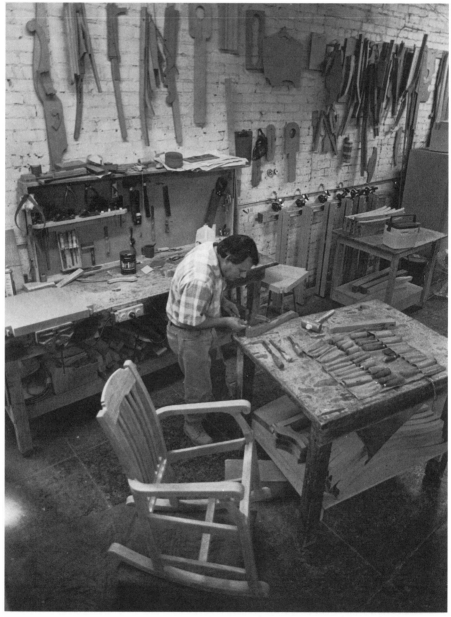

13 Luciano Valencia Figueroa working with wood at the Arroyo Design furniture factory. One of his rocking chairs sits in the foreground. Photograph by José Galvez.

Food as a Business

Another kind of "workshop" is that involved in the preparation of food. Eighty-six Mexican restaurants were listed in the Yellow Pages of the 1995 Tucson Telephone Directory. Among Tucson's Mexican restaurants, a surprising number are family operations, and the menu is originally based on the traditional skills and recipes of one family member, usually a woman. Most serve a standardized regional fare including hard-shell tacos, rolled enchiladas, flat enchiladas, burros, chimichangas, and tostadas—all dishes are adopted from traditional local home cooking. As is the case in any traditional art form, recipes and presentations vary from cook to cook, from restaurant to restaurant.

Although the primary enjoyment of food is in the eating, there is always a visual side as well. One doesn't always remember, when eating in a Mexican restaurant, that the often-seen combination of lettuce, sour cream, and red salsa is not just there because it tastes good—those are the colors of the Mexican flag![28]

Some restaurants specialize in food from other regions of Mexico. Fashions change in Mexican restaurants: Seafood restaurants specializing in Mexican dishes have increased in recent years, and the mid-1990s saw the founding of several establishments specializing in the soft tacos Sonorenses, or Sonoran-style tacos, made with soft corn or flour tortillas, filled with some sort of meat, and featuring a choice of condiments including salsa, lettuce or cabbage, lime juice, cucumbers, sliced red onions, and the like.

Since about 1991, a new kind of Mexican food establishment has become important in Tucson: the *carreta* or mobile taco stand. These converted travel trailers or motor homes have sprung up on street corners all over the southwest side of town. With their low overhead, they offer their operators a financially feasible alternative to a fixed-site restaurant. Aware that the fixed restaurants offer their customers visibility, comfort, and such amenities as restrooms, the carreta owners meet this challenge by offering elaborate, interesting signs and murals and such highly portable amenities as awnings, chairs and tables, and even artificial flowers in pots. Most striking of these carretas, perhaps, is Papa Chino's on South 12th Avenue, where the mobile

home is covered with an elaborate tropical mural painted by well-known local muralist David Tineo.

The carretas serve fast, inexpensive fare, concentrating on meat-filled soft tacos and burros, with perhaps a larger meat plate thrown in as a daily special. As an institution, carretas seem to be an adaptation of the various sorts of temporary food carts and booths that one sees all over Mexico. Like them, the carretas can be taken apart and reassembled each day. They are found almost exclusively on the southwest side of Tucson, adding greatly to that area's already strong Mexicano flavor.

Tortillas are necessary for almost any kind of Mexican cooking, and fewer and fewer women have the time (or the skills and desire) to make them daily at home. The answer to this problem is, of course, the tortilla factory. Tucson has at least fourteen of these, some of which do not appear in the Yellow Pages but must be found by driving the streets. Many make both corn and flour tortillas, using a process that combines traditional skills with machinery. The tortilla presses, conveyor belts, gas jets, and the like can take the product only so far; at some point, experienced individuals who have the know-how must take over to create a successful tortilla.

If tortillas provide Tucson diners with a link to a pre-Hispanic past, then it is Mexican baked goods that remind us strongly of the European side of Mexico's heritage. At any one time, there may be up to half-a-dozen Mexican bakeries in town, all employing bakers who have learned their skills through a traditional apprenticeship system. The bakeries (which tend to bake between the hours of three and six in the morning) produce several traditional kinds of cookies and *pan dulce* (sweet bread) in addition to the standard *bolillos,* or French rolls. Traditional cookies have traditional names, of course, and one can go to the bakery and buy *banderas* (flags—colored red, white, and green), *cochinitos* (little pigs), elotes (ears of corn), *huaraches* (sandals), *lenguas* (tongues), and many other shapes.

Certain kinds of bread are created only at special times of the year. In late October and early November, most of Tucson's Mexican bakeries make and sell *pan de muerto,* or Day of the Dead bread. These breads are intended to be consumed on November 2, All Souls' Day in the Catholic Church and the Day of the Dead for many Mexicanos.[29] Pan de muerto is most com-

monly made of a rich, egg-filled dough and covered with granulated sugar. The two most common shapes are a round loaf with little dough "bones" appliqued to it, and a loaf shaped like a person. In the mid-1990s, the baker at Alexia's Bakery on South 4th Avenue began creating loaves in the shape of skulls (fig. 14), whereas the El Rio Bakery on North Grande sells small "bones" of bread. In early January, some bakeries will sell *roscas de los Reyes*—the large, ring-shaped cakes with one or more tiny plastic babies baked into them. These cakes are used on January 6, the Day of the Three Kings, as described earlier in this book.

Mention of cookies and cakes brings us to sweets in general—an important element in the traditional diet of urban Mexicans and Mexican Americans. Since about 1990, La Jaliciense Mexican candy factory, now located on the corner of West 33rd Street and South 12th Avenue, has been filling at

14

Pan de muerto, or Day of the Dead bread, from Alexia's Bakery. The creator of these unusual skulls (the eyes are filled with colored fruit preserves) learned his skills in Guadalajara. Photograph by Dianne Nilsen. (Courtesy of The University of Arizona Center for Creative Photography.)

least part of this need. Mrs. Leonor Hurtado, wife of the owner/candy-maker Armando Hurtado, belongs to the third generation of a Jaliscan candy-making family. The Hurtados produce nine different kinds of candy, including candied barrel cactus and pumpkin, tamarind paste, and a number of confections based on heavily cooked, coagulated cream. Leftover sugar residue is made into *piloncillo,* or coarse brown sugar, which is sold to cooks and bakers. The Hurtados told us that there were many other kinds of traditional candies that they could make, but most either do not sell well here or are so labor-intensive that it would not be economical to make them. In 1996, the Hurtados sold directly from their store/factory, as well as to thirty-five retail outlets, including bakeries and restaurants.

The Mexican sweet tooth is further catered to by makers of two traditional frozen sweets: snow cones and *paletas,* or frozen fruit bars. Shaved ice cones are properly called "*raspadas,*" and locally, "*cimarronas,*" which is more correctly the word for mountain sheep. How this name came to be applied to the shaved ice cones is unclear, but the fact causes considerable merriment among Spanish speakers who grew up elsewhere. Raspadas have long been a popular summertime treat in Mexican American Tucson, especially because, until very recently, major ice cream stores were hesitant to locate on the southwest side of town. This gave full rein to stationary and mobile raspada stands, which sell their icy delights in a number of flavors.

Paletas, as they are known today, are closely associated with the Mexican state of Michoacán. Almost every paleta company and store I am aware of has some sort of Michoacano connection, and Tucson's Paletería Moreliana on West Ajo Way, named after the state capital, is no exception. Its owner, José Pedraza, is a Michoacano living in Phoenix, where the paleta factory is located. His son Gerardo operates the Tucson outlet, which daily sends scores of handcarts out into Tucson's barrios. The paletas come in about twelve flavors, including lime, tamarind, watermelon, mango, coconut, and strawberry. The clientele is 80 percent Mexicano.

Common Threads

One constant should be mentioned concerning all of these work settings. If the owners are Catholic, there will probably be a shrine to some favorite

saint or member of the Holy Family. Sometimes the saint will be one associated with a particular craft—boot makers often have altars to Saint Crispin and Saint Crispinian, patrons of shoemakers, on their walls.[30] San Martín Caballero is commonly accepted as the patron of businesses in general. Many Mexican restaurants have a shrine to the Virgin of Guadalupe somewhere near the main door or over the cash register. The altar may be in a prominent location, such as the ones at La Jaliciense candy factory and the ¡Aquí Está! furniture shop, or it may be unobtrusive. But it will often be there.

The professional craftsmen—furniture makers, metal workers, boot makers, cooks, and others—discussed above share certain characteristics. All are Mexican Americans, and all work essentially to order. Although each is capable of making a wide range of objects, in fact they must create what has been asked for, what will sell. They depend on the public for their livelihood. In some cases, the public wants traditional products—Mexican food, for instance, or decorative wrought iron using long-tested motifs. Even here, nothing is static. Fashions change, and the cowboy boots that are popular today might not be so in another ten years.

But for many of the craftspeople mentioned in this section, one must look past the product to find traditionalism. This quality lies in the apprenticeship system by which they learned their skills and in the division of labor that is so often an important part of the workshop scene. Traditionalism can be found in the vocabulary, the skills, and the attitudes they employ in their work, and in the very act of making a living through craftsmanship. A high percentage of Tucson's professional, commercial craftspeople are Mexican Americans who ply their trades on the south and west sides of town. Boot makers, furniture and door carvers, auto painters, upholsterers, and detailers—all partake in the centuries-old tradition of small craft shops, a tradition that is still viable in this particular place and time.

La Comunidad/The Community

A multitude of traditional art forms serve the community as a whole. These arts provide some of the "glue" that holds the community together and keeps it functioning smoothly. At the same time, arts serve to represent the community to the outside world. The community, of course, begins at home, and several art forms are intimately connected with the idea of family.

Paper Crafts

Several forms of art utilize colored tissue paper—*papel de china,* or "Chinese paper," in local Spanish. There is history hidden in this colloquial name. (In Spanish dictionaries, the term for tissue paper is *papel de seda,* or silk paper.) The treasure galleons that plied the Pacific from Manila to Acapulco in the seventeenth and eighteenth centuries brought the fabled wealth of the Orient to Mexico—pearls, gold, spices, jewels, ivory, and Chinese porcelain. They also carried an equally exotic but humbler product—colored paper, which could be made into flowers, cutouts, and other shapes. There is indeed a native Mexican tradition of making effigies out of folded and cut bark paper, but the colored flowers and other creations that are such an important part of Mexican folk art today seem to have had their origin in East Asia.[31]

Here in Tucson, papel de china is used for a number of things. Rectangles of colored paper may be folded and cut into various openwork designs. Unfolded, they become banderolas, or paper flags, which may be used to decorate an altar, a room in which a celebration is to be held, or—and this is a very traditional use in Mexico—the pathway over which a religious procession is to travel. María de Jesús Robles remembers such a use for banderolas in her native state of Nayarit, Mexico. Here in Tucson, she occasionally decorates Saint Augustine's Cathedral for special occasions (fig. 15). She also makes *farolitos*—little paper lanterns consisting of banderolas stretched over a rectangular wooden frame. Farolitos were also used to mark the pathways of religious processions. The paper folding and cutting technique by which both items are made is called *papel picado* or "pierced paper."

Paper flowers serve a variety of purposes. They decorate altars. They are placed on family graves on November 2, All Souls' Day in the Roman

Catholic calendar and *el Día de los Muertos* (the Day of the Dead) in Mexican culture. Paper flowers add to the festive *ambiente* (atmosphere) of weddings, baptisms, and other celebrations. Last but not least, they decorate booths at public fairs and fiestas, sending out a festive message of the Mexican culture.

A word should be said concerning el Día de los Muertos as it is celebrated in southern Arizona and northern Sonora. It is primarily a time for families to clean and decorate the graves of their dead. Some customs from

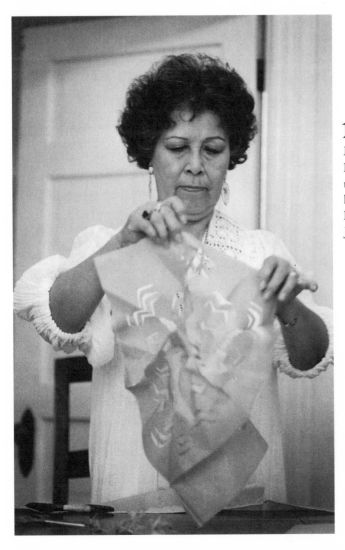

15
María de Jesús
Robles
unfolding a
banderola.
Photograph by
José Galvez.

the south, such as the use of marigolds, or *margaritas* (*zempasúchiles* in Mexican Spanish), and pan de muerto, or Day of the Dead bread, have been integrated into the local scene, but with a few exceptions, the dancing skeletons and candy skulls of southern and central Mexico have not made it up into the far northwest of Mexico. Where they do appear, they are generally introduced by professional artists and other intellectuals rather than existing as a Mexicano working-class folk custom.[32]

Most paper flowers in Tucson are made by members of the families that are planning to use them. Not so in Mexico, where paper-flower making can be a thriving cottage industry. Josefina Lizárraga, owner of West Boutique Florists on West St. Mary's Road, worked in a veritable paper-flower factory when she was growing up in Nayarit, Mexico. She and several other girls would go each day and reproduce several kinds of flower in paper. Her recipe for making the stamens of some flowers provides an example of the pains

16 Josefina Lizárraga making paper flowers in her florist shop. Photograph by José Galvez.

they took in their work. First, she would unravel a burlap sack to obtain the individual threads. She would grind rice in a *molcajete,* or small stone mortar, and mix up a batch of flour-and-water glue. Each thread would be cut to the appropriate length, dipped in the glue, and rolled in the rice powder to make it white. The end would again be dipped in glue and then in a yellow powder. This was just to make the stamens, which would then be inserted in the paper blossoms. Each week, shipments of completed flowers would be sent to the hotels in Acapulco and other west-coast resorts, where they would be used as table decorations.

As a result of this training, Ms. Lizárraga knows how to reproduce fifteen or more different kinds of flowers out of paper (fig. 16). Her work as a florist keeps her from doing this very often, but she does an occasional job for a movie on location, and now and then she teaches her skills to groups of adults and children at public festivals.

Cascarones

Cascarones are eggshells that have been cleaned out and refilled with confetti. Partygoers break them over each others' heads, adding to the festive ambiente of the occasion. Through the 1930s, cascarones were used by young, courting adults of both sexes; in today's Tucson, they are mostly the province of children. In most parts of the Mexican world, cascarones are simply blown and decorated eggshells, filled with confetti and plugged at the broken end with a bit of colored paper. In Tucson, however, cascarones have been elevated to an elaborate and exciting art form.[33]

The eggshell is usually placed on the large end of a paper cone six inches or more in length. This cone is decorated with strips of cut, fringed papel de china. Ribbons or even feathers may dangle from the narrow end of the cone. The eggshell is usually painted and may be decorated with glitter or sequins. The shell may even be painted to represent the head of a person or an animal. Pancho Villa and Adelita, Batman and the Teenage Mutant Ninja Turtles, skunks, snakes, and rabbits are all represented in contemporary cascarón art. A few artists have taken their innovations a bit farther than have others. One occasionally sees fully dressed cascarón figurines. In 1996, Lucrecia

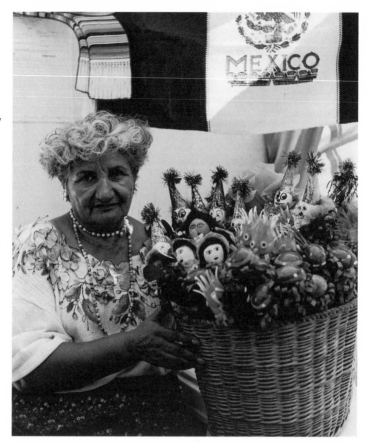

17
Angelita Montoya with a basket of her cascarones for sale at a public event. Photograph by José Galvez.

Montoya made fully dressed folklórico and other figures and sold them for six dollars apiece at public fairs and fiestas. Veronica Ahumada has started creating stemless cascarones, in which the egg, covered with little punched dots of different colored paper, becomes the body of an animal. Elephants, penguins, and, of course, dinosaurs are among her creations. Why the dinosaurs? Because cascarones are made to a great extent to appeal to children, and those huge, extinct "thunder lizards" have perennial kid appeal. Cascarones have become a highly successful commercial folk art form. They are sold at most public fiestas, school fundraisers, church bazaars, and cultural festivals on Tucson's west side (fig. 17); at two to three dollars apiece, they can bring a tidy profit to their makers.

Mexican Americans are not the only people making and selling

cascarones in Tucson. Yaquis and a few Tohono O'odham make them as well and sell them on public occasions. In fact, a Yaqui man might well have combined the stemmed cascarón, which has been made in southern Arizona since at least the 1930s, with the idea of converting the eggshell into a head. Feliciana Martínez, who seems to be the first person to make fully dressed figurine cascarones, is also Yaqui. Cascarones are not only being made by Yaquis, they also appear to be becoming integrated into Yaqui culture. For some Yaquis, the confetti that fills the cascarón has begun to take on a very traditional Yaqui meaning—it represents flowers and, through them, the grace of God.

As cascarones cross cultural boundaries, their use as well as their meaning may change. When Anglo American adults buy cascarones, they sometimes intend to use them as decorations for their houses or apartments. The colorful, inexpensive objects can serve as a statement of place, an identification of the householder with this particular region and its traditional cultures. And some cascarón makers have responded to this new use by creating large, purely decorative cascarones that are not intended to be broken. In the early 1990s at the Tucson Meet Yourself festival, Lou Gastelum and Virginia Yslas of the Club Los Chicos sold cascarones in which the "egg" was in fact a L'eggs pantyhose container! The inspiration for this innovation came from their university-aged children, whose friends wanted decorations for their dorm rooms and apartments. In fact, many of these decorative cascarones bore the letters "U of A" in red and blue—the University of Arizona's colors.

Piñatas

Piñatas are created out of papier-mâché and covered with cut, fringed papel de china. Like cascarones, they are pieces of folk art whose purpose is to be broken at parties. Piñatas are filled with candy and suspended from a rope. Party-goers—once again, mostly children—are blindfolded and given turns at trying to hit the piñata with a stick. When the piñata is finally broken, there is a mad scramble for the candies and other goodies that fall out onto the ground. (In recent years, an alternative kind of piñata occasionally has been made in which one pulls strings to release the goodies rather than whacking away with a potentially dangerous bat.)

Several professional piñata makers live in Tucson, and several piñata specialty stores are listed in the Yellow Pages. At many of these stores one can purchase not only the piñata but the stuffing as well. Each of these businesses will make piñatas to order. Other professionals work at home, filling custom orders or selling their wares through a wide variety of retail outlets. Fruit stands and party supply stores as well as many supermarkets sell piñatas, at least some of which are made by local professionals.

Such a professional is Jesús García. García learned to work with paper as a child in Nogales, Sonora, from his mother, María Antonia García. Sra. García sold paper flowers and piñatas to the curio shops of that border city and involved her children in the manufacturing process. Now, more than twenty years later, the Garcías live in Tucson, where Jesús has worked for the past ten years as an independent professional piñata maker (fig. 18).

Jesús García begins with newspaper, which he gets regularly from friends and neighbors. He paints the sheets of paper with homemade flour-and-water glue and then applies them over one of several stock forms. These forms—animals, humans, stars—are then modified to resemble the specific figure Mr. García wishes to make. Many of his shapes are built on a basic round form, made by wrapping glue-soaked paper around a discarded bowling ball. When the glue dries, the molded paper is cut off the bowling ball and extended with more papier-mâché to become a star, a rose, or a variety of other shapes.

This method of making piñatas differs from that used in northeast Mexico and along the lower Texas border, where the paper is formed around a bamboo framework. In other parts of Mexico this technique is used to create the framework for fireworks displays rather than piñatas. Traditionally in Mexico, clay pots are used as piñata bases, but many piñata makers in the United States believe that this is not legal in this country because of the safety hazards inherent in flying bits of clay pot when the vessel is broken.

The image is finished by gluing on strips of fringed papel de china. Mr. García says it bothers him "a little" to create works of art whose destiny is to be broken by children. However, he says, having broken one piñata, the family will have to come back and buy another for subsequent celebrations.

There seems to be a sort of built-in timeliness to piñata designs. An

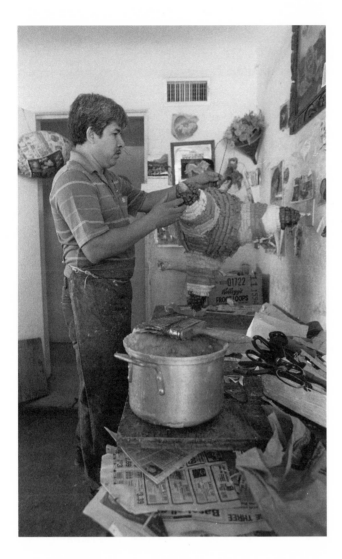

18
Jesús García making
a Star of Bethlehem
piñata. Photograph
by José Galvez.

account of piñatas in Mexico City in the 1890s includes fruit, flowers, ani-
mals, humans, and even devils on bicycles. This last shape may have been
influenced by the fact that the bicycle was the latest toy of the fashionable
classes; at least one contemporary high-wire cyclist in Mexico City dressed
up as the Devil. Today's piñatas include seasonal figures such as the Star of
Bethlehem, Christmas trees, and Halloween pumpkins; traditional Mexican
figures such as burros laden with flowers; and an ever-changing list of figures
out of popular culture: Bart Simpson, Darth Vader, and various superheroes.

Piñatas are for kids, after all, and kids want whatever character is "in" at the moment. This means that piñata makers must be skilled sculptors in papier-mâché, ready and able to start off with a cartoon clipping and end up with a three-dimensional figure between two and three feet tall.[34]

Not all the piñatas broken in Tucson are made by local professionals. Talented family members may create piñatas for domestic use, maybe making a few extras for friends and neighbors. And it is still more profitable for a large supermarket chain to ship piñatas in bulk from Mexico than it is to pay a realistic price to a local craftsperson.

Piñatas, cascarones, and paper flowers all serve to maintain the cohesiveness of the Mexican American family by making birthdays and other festive times more exciting, altars and graves more beautiful. But they also reach out to a larger community. Banderolas and paper flowers serve those who attend religious processions and public festivals by letting them know that this is indeed a special occasion, a time for festive thoughts and celebratory behavior. They also advertise in a public context the presence of an active, dynamic Mexican American community.

Objects for Weddings and Other Religious Events

Weddings are occasions wherein the family ensures its survival by taking on new members. Naturally, they provide another suitable opportunity for the creation of community-oriented arts. Weddings, for example, must have cakes. This is true in mainstream culture as well, of course. Mexican wedding cakes, however, can be very special and incredibly elaborate affairs, consisting not only of several layers but also of smaller, subsidiary cakes connected to the main cake by means of arches and even miniature staircases. Those parts of the icing that are not covered with flowers may be given a lace-like texture or some other surface manipulation.

Frieda Bornstein de Duarte was born in Mexico City and learned to make cakes in Nogales, Sonora. Her teacher, Victoria Sánchez, was originally from the west-coast state of Nayarit. Here in Tucson, Ms. Bornstein began making cakes for her family, and later obliged friends' and neighbors' requests for cakes. She once made a cake that served 1,200 people! Another had a small church on it with walls constructed of filigree icing. Her cakes

have been very innovative, with lights, fountains, and other details added to them. No longer able to create cakes because of her health, she nevertheless retains strong feelings concerning what Mexican wedding cakes (and by extension, *quinceañera* cakes) should be like.[35]

In her view, the very real differences between Mexican and American wedding cakes stem from a European aesthetic brought to Mexico in the 1860s by the French and Austrian court of the Emperor Maximilian. The Mexican cakes are simply more detailed—*más elaborados*—than those commonly found in the United States. "The Latino imagination, especially that of Mexicans, is fantastic," she says. "The Mexicano is capable of improvising." Ms. Bornstein is proud of her cakes for more than visual reasons. According to her, many people at weddings simply take one obligatory bite when the cake is passed around, but that never happened with her cakes. They were all eaten up.

Weddings, of course, need more accessories than simply cakes, and often these, too, can be provided within the community. Toni Aguilar, whom we first met as a deshilado artist, also creates such wedding necessities as embroidered cushions to kneel on in church, and little decorated bags for the bride to wear during the "dollar dance," a standard feature of Mexican wedding receptions. The men in the wedding party will take their turn to dance with the bride, each one giving her a gift of money in exchange for a short turn around the floor. Traditionally, the money is pinned to the bride's gown; the bags represent an innovation to help preserve the precious wedding gown from innumerable pinholes. For a later stage of married life, Mrs. Aguilar also makes christening gowns and baptismal clothing.

Continuing on the general topic of religion, the traditional ceremonies of the Catholic Church require a number of elaborately decorated items made of cloth. Altar cloths, napkins, covers for chalices and pyxes, and other church sacramentals must be used, and are often made by local women. Such an artist is Lupita Rubio, whose "day job" is with Saint John the Evangelist Church on the corner of 12th Avenue and Ajo Way. In her spare time, Ms. Rubio makes chalice covers and other ritual objects, most of which are presented to Saint Augustine's Cathedral. She cuts and sews the satin cloth into the desired object, and hand-paints delicate religious themes onto the cloth.

She also makes crocheted *lazos,* huge symbolic rosaries that are used during the nuptial Mass to tie the couple symbolically together within the confines of the Church. Artists in one medium frequently work in others as well; Ms. Rubio and her mother once made a twenty-five-piece nacimiento scene out of papier-mâché.

Tucson's Mexicano community sees itself as extending both backward and forward in time, and their celebrations include friends and family members who are deceased, as well as those who have yet to live out their lives. There are obligations to the dead, among which are the placing of suitable markers on their graves, and cleaning and redecorating those graves every year in time for November 2, el Día de los Muertos—the Day of the Dead. In the traditional rural graveyards that still exist on the outskirts of Tucson, the markers may be very elaborate indeed. At the León Ranch Cemetery near

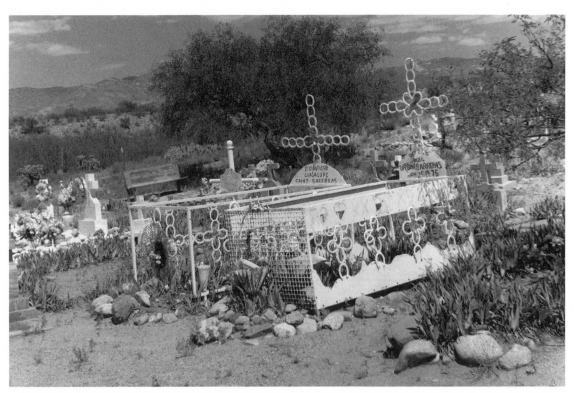

19 Graves at the León Ranch Cemetery east of Tucson. Note the decorative use of horseshoes to create crosses and floral designs. Photograph by Jim Griffith.

20
A death marker beside the railroad tracks south of Tucson. Crosses like this are often repainted and redecorated by family members, either on the anniversary of the death or just before All Souls' Day. Photograph by Jim Griffith.

Vail, southeast of Tucson, crosses and grave fences are made of horseshoes welded together in floral patterns and painted white (fig. 19). In modern, perpetual-care memorial parks within the city limits, where families are limited to headstones set flush with the ground, there are still opportunities for custom designs—a favorite saint, perhaps, or a reminder of the deceased's hobby—on the stone itself.[36]

And the seasonal floral decorations appear, even in the memorial parks where they are forbidden. Although they may be removed within hours by the park staff, the family's obligations to beautify the graves of loved ones have been fulfilled. In the same manner, the crosses families erect to mark the place where a loved one met a sudden death are maintained and seasonally decorated (fig. 20).

Low-Rider Cars

Art serves the general community in other ways, too. One of the most important is to strengthen the sense of community and the individual's bonds to that community by publicly reaffirming that community's social, religious, and aesthetic values. Take, for example, low-rider cars. These are automobiles that have been customized in special ways. The car body is lowered as far as is possible while still permitting ordinary street driving. Hydraulic lifts are often placed over each wheel so that each corner of the car may be raised and lowered independently (fig. 21). The exterior is given multiple coats of expensive paint, often containing metal flakes. Occasionally the exterior paint is of a uniform color, but more frequently it is shaded from dark to light or applied in a combination of colors. Detailing ranging from fine lines to mural scenes may then complete the body finish, although abstract graphics are currently replacing murals in popularity.[37]

Metal parts that are not painted are frequently chrome-plated. The interior is also customized with, for instance, swivel seats and a built-in TV set installed in front, and deep-pile, tufted upholstery covering the seats as well as lining the interior. The steering wheel is frequently tiny and made of links of chain welded in a circle and then chrome-plated. Thus equipped, the low-rider owner is ready for one of the intensely social activities associated with low riding. Many car owners belong to low-rider clubs. The names of many of the Tucson clubs—Society, Low Fantasy, The Classics—tend to project the same sort of image as do the cars themselves: elegant, even luxurious, with an emphasis on style. The club is one context in which low riders can see and be seen. Another is Saturday night cruising: Driving slowly down South 6th Avenue or South 4th Avenue, low riders socialize silently with the occupants of other cars in much the same way that young men and women traditionally strolled the plazas in Mexico earlier in this century, dressed in their finest, to see and be seen.

Many of these clubs engage in activities other than cruising or displaying their cars in shows. A strong thread of community service runs through many of the low-rider clubs I am acquainted with. One club may hire its cars out for wedding and quinceañera processions, charging just enough to cover the cost of gas and the necessary wash and wax job. Another may offer its

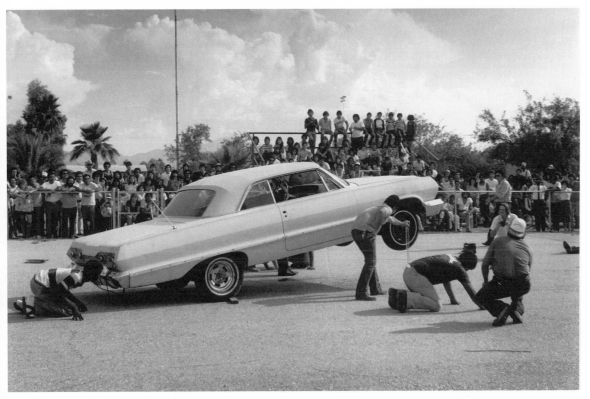

21 Hopping a low rider in competition at the Pima County Fairgrounds. Some low riders used in such competitions are not decorated, but just painted white, as this one is. Photograph by Jim Griffith.

cars to transport the Bishop and clergy to the annual Guadalupe Day Mass. A third may present antidrug and antigang programs in the public schools. A member of The Dukes, a local affiliate of The Dukes Car Club of Los Angeles, once explained the local meaning of the club's name to me: "*D*rugs are out, *U*nity is in, *K*ids are what's important, *E*ducation is what you need, and *S*chool is where you can get it."[38]

A third social context for low riders is the low-rider car show. Such shows can draw cars from a broader region than merely Tucson and are fascinating events to visit. Each car is displayed to its best advantage—often with one side, or even one corner, raised to give a sense of movement to the display (fig. 22). The cars are at their best here, polished, brushed, and vacu-

umed, with accessories such as cut-glass decanters and flowers arranged just so. One or more hand-painted signs usually proclaim the car's name—"Baby Blue," "Bad Enuff," "Uno Mas"—and list the painters, body shops, and others who have created this particular work of art. Accessories such as gas cans painted to match the car, stuffed animals, or even pedal-car miniatures of the larger vehicle may also be displayed, along with whatever trophies the car has won at previous events.

Who does the work on these pieces of art? To some extent, the owners and their friends and family, but there are also a number of professional craftspeople who will, if requested, assist in the creation of low riders. Such a craftsman is Carlos Gonzáles, who in 1996 owned Creative Trend Custom

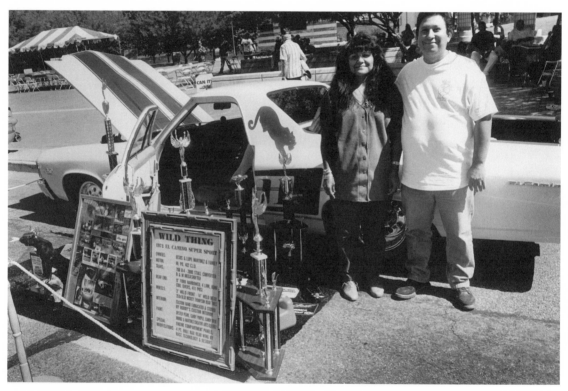

22 Jesús and Lupe Martínez with their 1973 El Camino Super Sport low rider. The occasion is the Low-Rider Car Show at the Tucson Meet Yourself festival, a multiethnic event. It is customary at shows for low-rider owners to display photos of their car as well as trophies and full credits for all those involved in its creation. Photograph by David Burckhalter.

Auto Interiors on Old Nogales Highway. Mr. Gonzáles has done four or five Chevrolet Impalas—a low-rider favorite—in his time. However, he prefers to do more contemporary interiors, giving them, in his words, the feel of an "airplane interior." He tries, sometimes successfully, to persuade his customers to leave the traditional low-rider look behind in favor of such contemporary styles. According to him, crushed velvet, which until recently was very popular among low riders, has the disadvantage of fading rapidly in Arizona's sunlight. Just how complex and luxurious are these interiors? One might get an idea from the fact that, according to Mr. Gonzáles, a really thorough interior job might cost as much as $50,000. Many of his customers come from Mexico, and he has also created interiors for cars that were sent to Japan.

Javier Rodríguez etches glass for low-rider windows. He got into this art form while he was at school, because it was "the thing to do." He has etched the windows of three or four cars in addition to his own. Designs he has done include a pirate scene, a Miller beer emblem, an eagle, a rose, a Cristo, and a Virgen de Guadalupe, complete with cactus. He did a Virgen de Guadalupe for his sister, which she keeps framed in her house. Rodríguez thinks low riding has lost a great deal of popularity here, but it seems to be coming back in California.

Low riding is not confined to cars; there are low-rider bicycles as well, and in the mid-1990s, Tucson boasted two low-rider bike clubs. One, Las Camaradas, was started in late 1994 by the owner of a South Tucson bicycle salvage shop. By April 1995, it had twenty-four members, aged thirteen to fifty-three, who got together at the shop on Friday evenings to work on their bikes and plan public appearances. In November 1996 I was able to identify a number of other such clubs: La Raza Unida, The Dukes Car and Bike Club, and Buen Estilo. The situation has undoubtedly changed yet again, with new clubs appearing and old ones fading out.

Low-rider bikes typically have small wheels, banana seats, and high, wide handlebars. Like the cars, surfaces are either chrome plated or richly painted. Bikes as well as cars may be seen at low-rider shows, and like the cars, they are displayed formally, often in roped-off areas, and often with such accessories as a rosary draped around the handlebars or a Mexican flag

spread over part of the bike. Truly elaborate displays may include strobes or floodlights, and the bike may even be placed on an electrically powered turntable.

Just as the car owners do, low-rider bikers cruise South 6th Avenue on a Saturday night to see and be seen. By means of both activities, both car and bike owners share their creations with their community, making a strong and traditional aesthetic statement to all who care to see.

In the late 1980s, I was attending a low-rider show that was part of La Fiesta del Presidio; at that time it was a part of the Tucson Festival season devoted to the celebration of local Hispanic culture and history. A mini-pickup had been lowered and fitted with hydraulic lifts. It was painted a rich canary yellow, and was waxed and polished for the occasion. The cab was filled with high-fidelity equipment, and a rock tune was playing full blast. The owner, casually but carefully dressed in black trousers, a club T-shirt, shades, and a narrow-brimmed hat, was standing to one side, operating the hydraulic lifts to make his car dance in time to the music.

About 100 yards away, another parking lot of the Tucson Museum of Art complex had been covered with sand. A member of the Tucson Asociación de Charros was standing in full, formal charro regalia on the silver-mounted saddle of his Palomino horse, which had been scrubbed, groomed, and combed until it fairly glowed. The charro was performing elegant, flowery figures with his rope while the horse danced in time to a waltz that was being played by a nearby mariachi.

It was then that I realized just how conservative a cultural statement is made by low riders. Like charros in contemporary society, low riders present an important aesthetic statement—the speed and efficiency with which you arrive are not as important as the style in which you travel. An excellent example of this as applied to the cars can be seen over the course of a Saturday night journey from East Speedway to South 6th Avenue. At the beginning of your drive, you will most likely encounter performance-oriented examples of mainstream Anglo American car culture. Powerful cars operated by young men will challenge each other by revving up at stoplights, and there may well be impromptu drag races. In contrast, the South 6th scene will be "low and slow; mean and clean," as low riders exasperate the more-hurried motorists by moving elegantly along the street, seeing and being seen.

Charrería

As low riders are to street rods, so *charreada* is to rodeo. Although both charreadas and rodeos derive from the work that vaqueros and cowboys must do in order to raise cattle on the open range (work and skills that the American cowboy learned from the Mexican vaquero), each sport has taken a direction dictated by the values of its own culture. Rodeo is about efficiency and timing. Cowboys compete to see who can stay on bucking broncos and bulls the longest, and they rope calves and wrestle steers to a clock. With *charrería* things are totally different. Elegance and style are what counts. In one event, for example, the charro, on foot in the center of the ring, spins his rope through a series of beautiful figures while a wild mare is driven in a clockwise direction around the edge of the ring. When she starts to run behind him, the charro turns, often stepping through his loop in the process, and ropes her. Grace and elegance all the way.[39]

Charrería requires special equipment. Saddles, for instance, must be made to a certain design, with huge horns and low cantles. José Villalpando, a craftsman originally from Jalisco who lived in Tucson for several years in the 1990s, made saddles, belts, and other pieces of leather equipment for members of the local charro association. Sr. Villalpando learned to make saddles by apprenticing himself to a saddle maker in Jalisco. He worked with him for eighteen years, then moved off on his own. During his stay in Tucson, he made saddles and other gear for members of the local charro association. Although he moved back to Guadalajara, Mexico, in September 1996, he is included in this survey because he seems typical of a certain kind of itinerant artist/craftsman who will stay in a single location while work is available, and then move on.

Sr. Villalpando got his saddletrees, or *fustes,* from Mexico; all other parts of the saddle he made himself from cowhide and strips of goatskin, which he used for the buck-stitching. Although his saddles were plain, he occasionally embroidered the owner's initials or brand with goatskin on a pair of chaps.

According to Sr. Villalpando, a charro saddle must be strong. It should also be relatively plain—excessive decorations don't fit in with what Sr. Villalpando considers to be a "natural sport." The saddle should be hand-made, he feels; a machine-made saddle simply does not have the proper feel-

ing—*"no luce igual"* (it doesn't shine the same). He makes all the leather gear a charro needs, except for boots. Other items of men's charro regalia must be imported from Mexico at considerable expense.

The women who participate in charreada do so in the form of an escaramuza or women's drill team. Riding sidesaddle and dressed in regional costumes from the state of Jalisco, escaramuza members perform intricate figures at a gallop. The escaramuza is intimately involved with an idealized view of Mexican history and the memory of the women who, riding with the men, played such an important part in various aspects of the Mexican Revolution of 1910–1920.

Costumes for the escaramuza are made by local seamstresses, who often do not work from patterns. These talented seamstresses use their skills to serve the community by stitching costumes for relatively small sums. Such costumes would be prohibitively expensive were they to be purchased commercially.

These same women use their skills to serve the community in other ways, too. It is to them that mothers turn when their daughters need folklórico costumes. And it is to these same immensely skilled women that a mother and daughter can go, bridal magazine in hand, confident in the seamstress's abilities to go from a photograph of the latest style to a complete wedding gown without a printed pattern.

Prison Art: Tattoos, Paños, and Other Crafts

Community can be tremendously important for those who, for one reason or another, are kept from full participation in that community. One way in which isolation occurs is when an individual is incarcerated. Prisoners can express their cultural, religious, and aesthetic heritage in a number of ways. One of these is by being tattooed (fig. 23). Not all prisoners are tattooed, of course, and not all Mexican American and Chicano men who wear tattoos have ever been in prison. But a large percentage of Chicano prisoners do acquire tattoos, and the content of those tattoos is frequently cultural. Religious figures, especially various representations of the Virgin, are especially popular, as are representations of flowers and women's names and faces. The prison tattoos are forbidden by the authorities for safety and other reasons, and are executed secretly using homemade equipment, which is itself liable to confiscation.

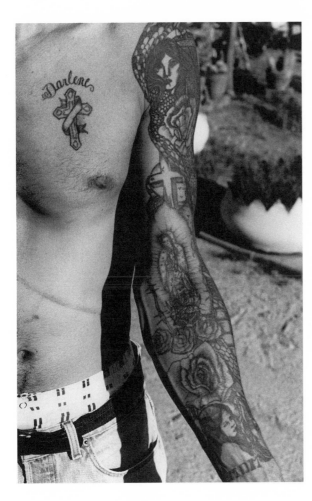

23

The late Eddie Álvarez showing his tattoos. Our Lady of Guadalupe, beautiful young women, a cross, roses, and other motifs are all combined in this elaborate and wonderful piece of work. Photograph by Jim Griffith.

A more tolerated form of prison art is the making of *paños,* or decorated cloths. Handkerchiefs are drawn upon with pens or colored pencils. No systematic survey of the paño scene has been done in Arizona, but Rudy J. Miera, an Albuquerque writer, has characterized the five main paño subjects as *la vida loca* ("the crazy life" or street life), *queridos* (scenes evocative of romance), *protesta* (Chicano history and resistance), decorative motifs, and religious or spiritual topics. Sometimes these paños are framed in elaborate frames made of toothpicks or match sticks (fig. 24).

Using these same motifs, prisoners also etch designs in insulated plastic mugs and draw elaborate pictures on the envelopes they send to friends and relatives on the outside. Another favorite craft pastime is creating woven crosses out of thread, perhaps unraveled from a sock or some other bit of clothing. Bits of foil from cigarette packages may be turned into frames or

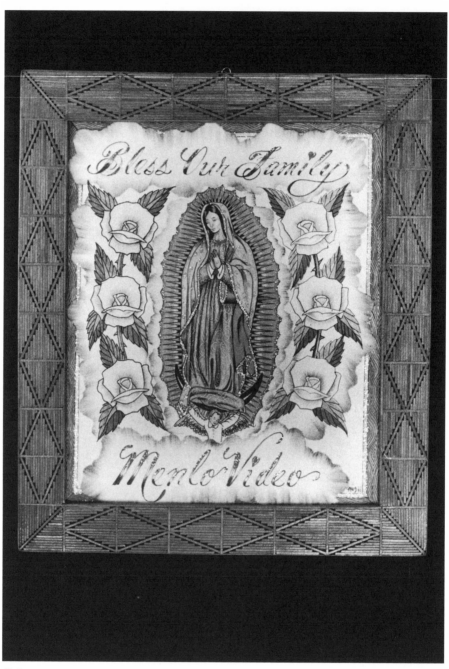

24 A paño with the Virgin of Guadalupe and a loving message to someone on the "outside." The frame is made of wooden match sticks. From a private collection. Photograph by David Burckhalter.

such items as miniature baby booties. Regular crafts programs may result in the prisoner creating religious images out of copper or even fused glass— images that may end up displayed on the wall or altar of a family member (fig. 25).[40]

25
More prison art. The bible, the cross, and the corpus are all hand-made out of papier-mâché, and the text is hand-printed. From a private collection. Photograph by David Burckhalter.

Folklórico Dance

As Mexican Americans have increasingly come to see themselves as a potentially powerful community that is distinct from the mainstream of American popular culture, they have increasingly projected that sense of community to the outside world through aesthetic presentations. One such presentation is folklórico dancing. Increasingly popular since the 1940s, folklórico dance troupes present formalized, costumed, and choreographed versions of

Mexico's traditional regional dances to audiences on formal occasions. The folklórico movement has been a part of Tucson since at least the 1930s, when Marguerite Collier formed the Mexican Culture Club at Carrillo Elementary School. The club presented the Christmas drama *Las Posadas* and regional dances from various parts of Mexico for outside audiences. Photographs from the thirties, forties, and fifties in the archives of the Southwest Folklore Center show Carrillo students dressed in traditional costumes from Jalisco, Michoacán, and other major cultural regions in Mexico.

Folklórico dancing received tremendous impetus in the 1970s with the work of Ángel Hernández, who studied in Guadalajara at both the university and the Instituto de Bellas Artes. For several years, Hernández led the Baile Folklórico de Pima Community College before forming his own Baile Folklórico Mexica, which has continued since Hernández's death in October 1987. Today in Tucson, several large and small folklórico groups are active. Some are sponsored by specific elementary, middle, and high schools; others involve adults as well as children. All present similar versions of the great dances of Mexico—Jalisco, Veracruz, and Chihuahua being among the most popular states to be represented.

Folklórico dancers must have costumes, and most groups know one or more women who are willing to employ their skills and talents with the sewing machine to create the several outfits that an active group must use in the course of a long performance. The folklórico seamstress serves not only the smaller community of the dance group but also the larger community, Mexican American and Anglo, who benefits from this exciting and educational public dance form.[41]

While folklórico mostly emphasizes the contemporary aspects of Mexico's cultural heritage, a few individuals within the community look farther back in time for their models. Rogelio Valdovín, at the time working as a school custodian, had a vision in the 1970s in which he was commanded to celebrate Mexico's Indian heritage by making and wearing Aztec costumes. That very evening he started working on the first of several such costumes, which he wears at religious processions and cultural events such as the annual Rodeo Parade. The costumes, extremely elaborate confections of feathers, cloth, and various kinds of artificial gems and glitter, come from his

imagination, sparked by pictures in books. There is one constant: Every one of his costumes has somewhere on it an image of the Virgin of Guadalupe. Over the years he has taught apprentices, and now several Tucsonenses occasionally appear in Aztec regalia.

The contemporary, ritualized use of Aztec costuming has analogies in other parts of the Mexican world, when groups of ritual dancers calling themselves "Aztecas" or "*concheros*" (shell-carriers, after the armadillo-shell mandolins they sometimes play) perform at religious fiestas.[42]

Folk Music and Dance

Music seems to have always been a part of local Mexican American culture. One of Tucson's first formal musical ensembles, the Club Filharmónica, was formed in 1889 by Sonora native Federico Ronstadt.[43] Ronstadt continued to be active in Tucson's music scene and passed his love for singing on to his descendants, including the internationally famous Linda. In 1994, the Ronstadt family received a Copper Letter (Tucson's equivalent to the Key to the City) for having made the city's air beautiful with song for more than 120 years. Some of the songs still sung in the family were brought from northern Sonora by the young Federico Ronstadt y Redondo in the 1870s.

Like so many other art forms, music is used by many Mexicanos in service to the community. Music makes celebrations a little more exciting, grief a little easier to bear, worship a little more beautiful. It is not unheard of, even in today's Tucson, for a group of musicians to appear under someone's window before dawn to give them a *serenata de gallo*—a predawn serenade—on a day that is special to them. Musicians are often called on to make their specific social contributions at a wide number of occasions—birthdays, baptisms, First Holy Communion parties, weddings, graduations, Rosaries, and even wakes and funerals. Although money usually changes hands at such times, there is a very real sense in which the musicians feel obliged to "help out" within the context of either family or community. Incidentally, when local musicians are to be paid, they say, "*va a llover*" (it's going to rain). If the fee concerned is particularly generous, the phrase is "*se van a caer rayos*" (lightning bolts will fall).

The music itself may be of several kinds. *La música norteña* (northern

music) is the music of choice for many older, working-class Mexicanos in Tucson, as it is all along the border. Originally from the Texas-Mexico borderlands, norteño music features the button accordion or saxophone as the lead instrument, with rhythm provided by drums, a bass, and a twelve-stringed bass guitar, called a *bajo sexto*. The musicians dress cowboy style, and the repertoire includes polkas, waltzes, *corridos* (ballads), boleros, and other popular dance rhythms and song types.[44]

In the early years of this century, mariachi music was the regional folk music of the state of Jalisco, in west central Mexico. Over the years, thanks to phonograph, radio, and motion picture exposure, and as a result of deliberate cultural engineering in the 1930s on the part of members of Mexico's revolutionary intellectual elite, it has become the musical symbol of Mexican culture. In Tucson, mariachis are as likely as not to belong to the younger, professional classes and usually play elaborate arrangements of the *sones* and *canciones rancheras* that make up the standard international mariachi repertoire. Mariachis also appear in several westside churches, including Saint Augustine's Cathedral,[45] often playing at regularly scheduled "mariachi masses."

There are other types of musicians in the community as well: older instrumentalists who maintain a basically nineteenth-century repertoire of waltzes, polkas, guitar duets, and trios; the modern Tex-Mex bands; and orchestras and combos specializing in *cumbias* and other Caribbean rhythms, among others. Many of the performers in these genres serve the community in the special ways mentioned previously in addition to their work as musical professionals. And that is, perhaps, the most traditional thing about much of Tucson's Mexican American music: It functions within a family- and community-oriented society, serving the needs of that society.

There used to be instrument-makers within Tucson's Mexicano community as well, but with one exception—a harp maker—they no longer exist. Mexico is simply too close to allow an instrument maker to make a living among working-class folks. A major north-south highway connects Tucson directly with such great Mexican instrument-making centers as Paracho, Michoacán.

Music can be danced to, of course, and there is a wide range of tradi-

tional social dance practiced in the Tucson area. Most distinctive, perhaps, is the regional polka step, which is found all through the border country. It is a one-step, and the couples move around the floor counterclockwise in time to the music. It can involve complex and decorative turns, swing-outs, and side-by-side promenades, and it is enchanting to watch a practiced couple moving around the floor with grace and dash.

Songs have words, and the verbal arts are perhaps the most prevalent forms of traditional expression in Tucson's Mexican American community. Most members of that community have a stock of songs, recitations, traditional jokes and stories, proverbs, and sayings, and use them to enrich their lives in appropriate ways. A surprising number of people try their hands at composing ballads or corridos about current events of community significance. Wordplay calls upon a sense of playful ambiguity that is dear to the hearts of many Mexicanos, and bilingual wordplay in both English and Spanish is a common form of regional humor.[46]

Painted Walls

Like folklórico dancing, painted walls serve to reinforce traditional values within Tucson's Mexicano community while advertising the community in positive ways to the outside world. As one moves closer to the city's downtown area and to its south and west sides, the number of painted walls increases dramatically.

Most obvious, perhaps, are the walls that are simply painted with brilliant colors. Mexicano-owned stores on South 4th, 6th, and 12th Avenues may be red, green, orange, blue, or other shades, proudly proclaiming without the need for printed signs, *Aquí se habla español*—"Spanish spoken here."

Store fronts and windows are often painted with advertising of some sort—it seems more common on the southwest side than in other parts of town. Sometimes the name of the business is painted on the wall in decorative letters. Sometimes, as in the case of the Regis Bar on South 12th Avenue, or the Specialty Auto Electric Company on West 29th Street, the painting represents the goods available within—a can of Tecate beer or various kinds of automobile generators. This kind of advertising painted on walls can be seen all over northwest Mexico. Many in Tucson seem to be done by itiner-

ant sign painters who move around town looking for work, and then perhaps move on to another city. Others are done by more established artists.

Sometimes the advertisement reaches enviable heights of imagination. El Vaquero Marinero (The Seafaring Cowboy) was the name of a Mexican seafood restaurant that stood on South 12th Avenue in the early 1990s. Its advertising panel, painted by muralist Paul Lira, showed a Sonoran cowboy, complete with checkered shirt, boots, straw hat, and pistol, riding a bucking shrimp in the Gulf of California, with a shrimp boat in the background. Another of Lira's paintings advertised Lizárraga's Restaurant on North Grande with El Chilito Bandido—a red chile wearing a sombrero, boots, and cartridge bandoliers. Lira continues to be a highly prolific sign painter, and his work frequently demonstrates a sense of humor.

It is but a small step from the business mural, which refers in some way to the goods or services provided within, to the purely cultural mural. Here, too, Tucson is exceptionally well-endowed. "Artistic" or "cultural" murals, as one might call them, appear on many walls all over Tucson's west and southwest sides. They come, and sometimes they go, as did the Perfection Plumbing mural on South Park Avenue. The mural, originally painted in the 1970s by Hermosillo, Sonora, native Antonio Pazos and a group of Tucson High School students, featured a wonderful collection of images having to do with Chicano identity. Low-rider cars, the Catholic Church, Mexican revolutionaries and the Farmworkers' Movement, Aztec pyramids, and prickly pear cactus all joined with the ubiquitous Virgin of Guadalupe to form a Chicano iconography for the last quarter of the twentieth century. The mural was painted over in the 1980s after graffiti defacement and a change of the building's owners.

A group of early murals that are still in existence adorns the El Río Neighborhood Center on West Speedway. The center itself came about in 1972, after a group of neighborhood activists learned that the City of Tucson was expanding a golf course used primarily by affluent nonresidents. A strategy of marches, demonstrations, and meetings finally succeeded in persuading the city government to accede to the demands of the barrio residents. This became a turning point in the struggle for political power on the part of westsiders, and the event was celebrated in 1975–76 with a series of murals, created first by Pazos and later by his student David Tineo.[47]

Tineo, now one of Tucson's established muralists in his own right, has done many murals since the 1976 *El libro y la esperanza de nuestra raza* (The Book and the Hope of Our People) on the south wall of El Río Neighborhood Center. He is responsible for twenty-seven of the 190 works catalogued in the *Guide to Murals in Tucson*[48] and has done many others that, for one reason or another, have not been listed. Although some of Tineo's paintings, including his *Compass to the Southwest* (1988) on the University of Arizona Press building on North Park Avenue, were done by him alone, much of his work has been done with school children.[49]

School murals deserve mention in their own right. Many schools have received grants, often from the Arizona Commission on the Arts, to get their students involved in public art projects, including murals. The results are more than a group of charming murals decorating the exterior and interior walls of neighborhood schools. They also include an increasing number of young people who feel it is a perfectly natural thing to plan and execute murals—a group of young artists who will probably leave a very lovely mark upon their community in the years to come.

Not all school projects are limited to murals. At Wakefield Middle School, for instance, a program funded by several agencies resulted in some impressive mosaics done by Mexican American and Yaqui students. Among the mural-sized pieces produced were a low-rider car and a Virgin of Guadalupe.

Luis Gustavo Mena is the third of Tucson's "Big Three" muralists. Unlike Pazos and Tineo, Mena does much of his work on the walls of commercial buildings, although many of his subjects—such as *Benito Juárez* (1981) on the north wall of a hairdresser's studio across 12th Avenue from Pueblo High School—are deeply connected with Mexican culture and history. Mena is also responsible for the *Pink Cadillac* mural (1985) on the side of a car wash on South 12th Avenue and the pre-Columbian procession *Mixteca Royal* (1985) on the north wall of the Xochimilco Restaurant on South 4th Avenue.[50]

Chicano murals are being created in Tucson by an increasing number of artists. In 1993, for example, seventeen-year-old Ruben Moreno got a grant from the City of South Tucson to paint a mural on a particularly graffiti-prone wall, and then executed it in three days with the help of twelve friends and family members. The mural, on the wall of Ronquillo's Bakery (now the

La Jaliciense Mexican candy factory) at the corner of South 12th Avenue and West 33rd Street, contains references to several of Tucson's cultural traditions. One of the main groups of figures is an Aztec warrior and a Spanish conquistador touching fingers in a visual reference to Michelangelo's *Creation of Adam* in the Sistine Chapel. Moreno has since done other mural projects and is working toward becoming a professional artist.[51]

A more recent mural appears on the west wall of the Holiday Mart convenience store on West 22nd Street. Immediately after the University of Arizona Wildcats won the NCAA National Basketball Championship in April 1997, Ismael "Izzy" Galindo approached Ronald Lee, owner of the store, with a request: He wanted to paint a commemorative mural. Lee gave his permission, and Galindo assembled the necessary supplies, recruited fifteen teenagers from the Santa Rosa Recreation Center, where he was a recreation worker, and set to work. The mural, which includes portraits of the major team members as well as Coach Lute Olson, still stands, reminding its viewers of a proud day in Tucson's recent history.[52]

There is another side to Tucson's painted walls—graffiti. In a sense, the only difference between graffiti and murals lies in whether or not the artist had permission to do his or her work. Some of the illegal "tags" or *placas* one can see around town are actually carefully conceived and well-executed works of art. They certainly follow rigorous conventions, like all of the traditional art we have been discussing. Although the ranks of the local "taggers" certainly include Chicanos, whether these paintings, inspired for the most part by work done over the past fifteen years in New York subways, reflect a Chicano or Mexican American aesthetic is unclear. They do, in the sense that wall-painting itself is an important Mexicano cultural tradition. In the matter of style and subject matter, however, I am not so sure.

The techniques of spray-can painting, developed and polished for the most part on illegal tags and "pieces" (short for "masterpieces"), are being used for other purposes as the graffiti artists grow older and attempt to move into the mainstream. In October 1998 a painter who signs himself "Daze" was working by request on the walls of Big Ed's Detail Shop on South 12th Avenue. He was creating, appropriately enough, a series of murals depicting vintage cars, using spray paints exclusively. He told me he was interested

mostly in gaining fame through his work, in seeing signed pieces of his on the Internet, for example. When asked if there was any way of distinguishing Chicano pieces from those of any other culture, Daze replied in the negative.

Walls where tagging and signing are formally permitted come and go in Tucson. In 1998, one such wall was on the Gizmo Factory, a silk-screen print shop on South 12th Avenue. The business had a policy of permitting graffiti artists to display their work on its walls, after preliminary approval by the owners. Paintings remained up for about a month and were then replaced. Memorial paintings, dedicated to departed friends, remained on the walls longer.[53]

Just as some wall paintings advertise stores, some graffiti carry specific messages concerning the use of space—in this case, they serve as markers for gang turf. These gang graffiti, although often placed for purposes contrary to those of organized society, display a certain style. Such graffiti are but one more example of the importance within the general Mexicano community of walls as a medium for public communication.

Some of the art that teenaged Chicanos create reflects cultural heritage in other ways. Examples may be seen in the drawings of low riders, zoot-suited Chicanos, and even standard cartoon characters with Chicano details that some young men put in their sketch pads and school notebooks. Sylvester the Cat, for example, may wear a big sombrero and play the guitar, whereas Bugs Bunny, complete with bandana handkerchief, cruises in his low rider. In this way, mainstream American images are appropriated and given a strong Chicano flavor. Other examples may be seen in airbrush work on custom T-shirts. Many of these young artists go on to other things; a few keep their skills alive and polished and move into the ranks of artists who serve their community in the ways I have discussed above.

What do all these disparate art forms—murals, music, low riders, charro saddles, piñatas, and many others—have in common? They all serve the Mexican American community in one way or another. By making celebrations more intense, by affirming community values, and by projecting these values to the outside world, each in its way strengthens the sense of community, and by doing so, strengthens the community itself.

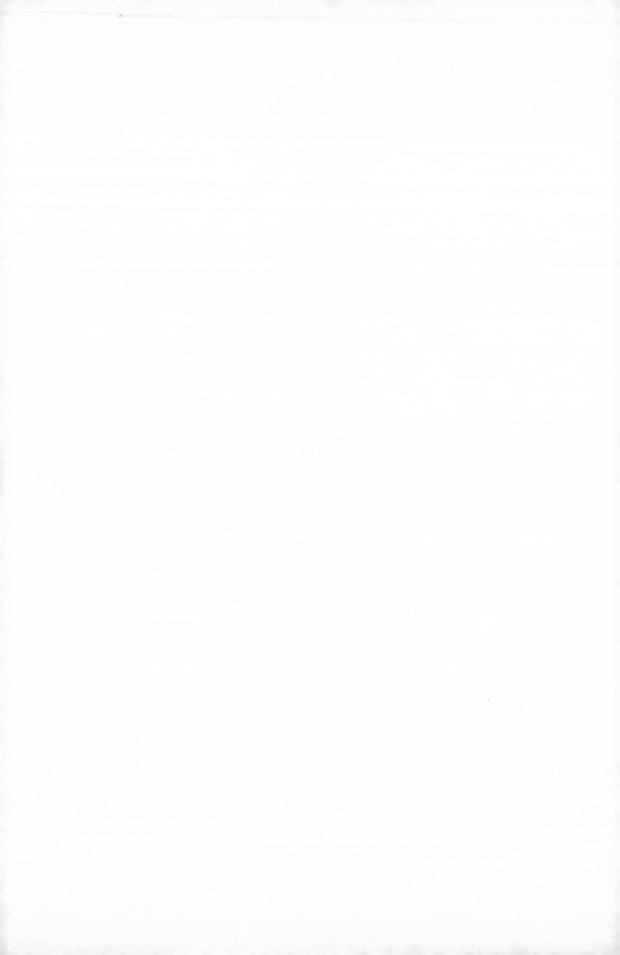

III · Patterns and Processes

So far I have been describing the traditional arts of Tucson's Mexican American community almost completely in the context of that community alone. But Tucson is a multiethnic city, and Mexican Americans are not the dominant culture. Although in recent years the Mexican culture has received considerable favorable attention from the newspapers and other media, it is perfectly possible for an Anglo American, especially an affluent Anglo American, to live a full life in Tucson and have few social contacts with Mexican Americans. Those Anglos who have adopted aspects of Mexican American culture have done so by choice.

These choices seem to be of several kinds. Many Anglos, although not acquainted personally with any Mexican Americans, may nevertheless partake of some aspects of regional Mexicano culture, especially food. A wide range of Mexican restaurants is available, from those catering almost exclusively to Anglos to those catering to both Anglos and Mexicanos. In addition, many Anglos make some adaptation of traditional Mexican food at home. The most popular homemade dish is perhaps salsa. But for many Anglos, salsa is not what it is for Mexicanos—a condiment one puts on one's everyday meals—but rather a specialty food that is usually eaten with chips before or between meals, especially when one is entertaining company.

Even the name of the condiment can change as it crosses cultural boundaries. "Salsa" simply means "sauce" in Spanish, and there are many different kinds of salsa, including salsa *inglés,* or Worcestershire sauce. In general, however, the Anglo community considers salsa to be made of chopped tomatoes, onions, chiles, and other ingredients. The proper Spanish term for this particular salsa is "salsa *cruda*" (raw sauce) or "salsa *casera*" (home-style sauce). In regional English they are simply called "salsa." I have even seen a commercially produced salsa cruda labeled "salsa sauce."

No longer an ordinary household condiment, this kind of salsa has become for many an ingredient in a new, exciting regional lifestyle. Salsa manu-

facturing companies catering to this segment of the population market their product with such exotic visuals as Spanish or Mexican women or southwestern scenes that have little to do with either Mexican culture or food.[1]

For many Americans, Tucson is part of an exciting, even exotic, region—the Southwest. Viewed as a unified region by many, the Southwest consists of Arizona and New Mexico, along with adjacent parts of California, Utah, Colorado, and Texas. Many of the cultural characteristics that define this dry region stem from the fact that for centuries it was not the Southwest at all, but the Northwest. Prior to the mid-nineteenth century, it was northwest Mexico, and before that, northwest New Spain. For several hundred years before the arrival of the Spaniards, it seems to have been on the northwestern receiving end of cultural impulses from the Valley of Mexico. It is this Mexican flavor, both ancient and modern, that gives the southwestern United States much of its "otherness," and makes it such a fascinating place for Anglos to visit and live in.

Several other art forms that Anglos have borrowed seem to have been reinterpreted in the borrowing process. Many Anglos purchase *cascarones,* not to break over people's heads at a party, but for wall decorations. Piñatas and paper flowers can be used in the same way, thus becoming symbols of a special place rather than tools to make social gatherings more successful. This is not, of course, a hard-and-fast rule. Some Tucson Anglos have never seen, much less purchased, a cascarón. Others use piñatas, cascarones, and paper flowers for their traditional purposes, whereas some Mexican Americans, especially those living in Anglo neighborhoods, may use them for decorations.

The *papel de china* articles mentioned earlier, although purchased by Anglos, are still for the most part made by Mexicanos. Rawhide braiding is another matter. A number of essential pieces of cowboy and vaquero gear may be made of braided rawhide, among them *bosales* or nosepieces for hackamores, reatas, and reins. Although this craft is still pursued in Sonora, it has nearly died out among Arizona Mexicanos. A few Anglo cowboys do braid rawhide, however, and to the extent that the skills to do so still exist in Tucson, they exist in the Anglo world.

Still other art forms have not crossed over into the Anglo world. The

Anglo establishment has yet to be totally comfortable with low-rider cars, for instance. It is interesting to note that, until 1999, few books were published on low riders.[2] One arts magazine in Tucson received complaints from advertisers after running a photograph of a low-rider car on its cover. There is something about the cars—or their owners—that seems to disturb some members of mainstream society. The Tucson Meet Yourself folklife festival held annual low-rider shows in the 1980s and 1990s, and received only one or two complaints during that time.

Native Americans in Tucson have adopted—and adapted—some art traditions from the Mexican American community as well. Flowers have a special significance in Yaqui ceremonial belief; some Yaquis believe that when Christ was dying on the cross, flowers sprang up where His blood fell to the earth. For many Yaquis, flowers are blessings—visible signs of God's grace. For these and other reasons, paper flowers need to be created for Yaqui altars. Certain women in each Yaqui community near Tucson have gained reputations as being experts at making paper flowers, and roses in particular.

For Tohono O'odham as well, paper flowers are important additions to altars as well as to the graves of loved ones on All Souls' Day. Both Yaqui and Tohono O'odham paper flowers may be embellished by dipping the edges of the petals in glue and then sprinkling them with metallic glitter.

Cascarones have also been adopted by O'odham and Yaqui craftspeople. The series of innovations that led to the distinctive Santa Cruz Valley style of cascarón was helped along by a Yaqui artist. By combining the painted-face cascarones he used to make as a boy in California with the paper stems he found here in southern Arizona, this man made possible the increasingly elaborate figurine cascarones that are now made in Tucson. A further step was taken in the late 1980s, when a Yaqui woman created cascarón figures dressed in *baile folklórico* costumes as raffle prizes for various Yaqui-related causes.

Nor are papel de china and cascarones the only areas in which Yaquis have adopted traditional Mexicano art forms and made them their own. Yaqui front yards and yard shrines in Tucson may have such a baroque elegance and attention to color, detail, and multiple images and meanings that it is impossible to distinguish a Yaqui yard from a Mexicano yard without interviewing the owners and makers.

The sheer range and variety of the arts I have chosen to discuss are tremendous. Food, paperwork, home altars, low-rider bikes, boots, ironwork, even neon—how can there possibly be any common thread that binds all these together? No single thread, perhaps, but certainly some themes run through all the material I have been discussing.

One is the persistence of the baroque as a model for organization. Mission San Xavier del Bac, a few miles south of Tucson, stands as a sterling example of the late eighteenth-century baroque style of New Spain. One doesn't have to look long at the living traditional arts of Tucson's Mexican American population before one realizes that the principles that guided the organization of this rich and complex body of art are still valid in later twentieth-century Tucson. A sense of motion; dramatic contrasts; richness of materials, colors, and detail; even a sense of ambiguity and a fascination with multiple meanings—all serve as ground rules for much of the art we have been discussing. Even such truly contemporary art forms as low riders, and especially low-rider displays, are assembled according to baroque rules and principles. And surely, if the builders and decorators of San Xavier had had access to neon, they would have used it.[3]

Many of the art forms I have been discussing involve recycling. Front yard shrines and decorations, cascarones, benches, barbecue pits—all these and other objects may be constructed at last in part from already-used materials. While this is certainly a practical matter in many cases, the layering of meaning that is inherent in recycling also fits perfectly into the general baroque patterns mentioned above. Just as words are recycled in popular Mexican American wordplay to give delight through multiple layers of meaning, so too do recycled objects gain interest through the various meanings they can bring with them into their new environment.

The imagery of the Catholic religion is another theme. Sacred images can appear in virtually every domestic and commercial setting. Our Lady of Guadalupe, for instance, is truly ubiquitous—she appears on altars, murals (fig. 26), and T-shirts; etched into low-rider windows; and in the art of prisoners. She enters into every aspect of life, connecting it with the eternal values of heaven.

Mexicano identity is a constant theme. Every time an artist follows the

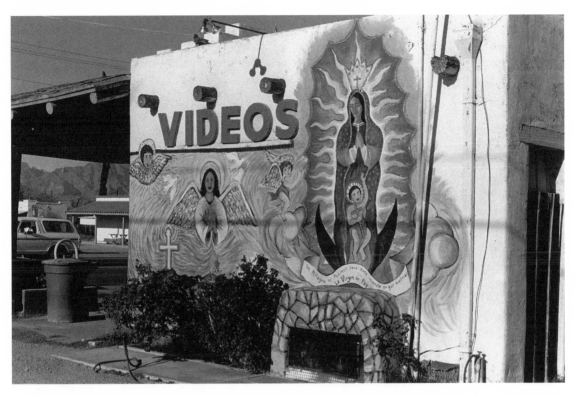

26 Menlo Park Video store. This image of our Lady of Guadalupe is the third such mural to appear on this store. The owner has a strong devotion to the Virgin. During the Gulf War, the doors of the small nicho were left open for those who wished to pray and offer lighted candles. Photograph by Jim Griffith.

traditional Mexican aesthetic or uses traditional Mexican images, he or she is affirming Mexican cultural identity. Our Lady of Guadalupe is not just an important Catholic figure, she is a specifically and peculiarly Mexican one. It was near Mexico City that she is believed to have appeared to a Mexican Indian for the purpose—as many believe—of bringing Spaniard and Indian together to form a new identity. In another statement of *mexicanidad,* the colors of the Mexican flag appear over and over again, even on food in restaurants. Many of the artists we interviewed spoke of the Mexican-ness of their art. Time and again they expressed pride in their Mexican identity and in their ability to express that identity artistically.

Ethnic identity becomes more important, of course, when that identity is threatened or disparaged, and many of the art forms of Mexican American

Tucson seem to be reactions to the dangers of submergence in a sea of indifferent or even hostile popular culture. Murals, folklórico dancing, low-rider cars and bikes, even yard shrines—each in its way expresses a reaction to being a cultural minority. In her study of religious art in the Mexican American communities of the Lower Rio Grande Valley, Cynthia Vidaurri found that the community that had by far the most yard shrines was one where Mexican Americans were to some degree an embattled cultural minority.[4]

Last, and perhaps most important, is the sense of community. Beyond the category of arts I have labeled *"comunidad,"* it permeates all the traditional arts of Mexican American Tucson. So many of the arts function within a family context. Families extend horizontally through distant relations by

27 María Gonzales in her Menlo Park Video store. Some of Ms. Gonzales's collection of pictures of the Virgin may be seen on the walls. Photograph by José Galvez.

marriage and vertically to include the generations now passed. Like a thread in a piece of embroidery, family connections tie a community together, and many of the artists presented in this book are themselves related to each other in complex ways.

Community also exists in the sense of people to be served, people to get along with. The culture we are dealing with has a tradition of city dwelling that goes back at least two thousand years on both sides of the Atlantic, and a sense of community is vital to survival in an urban setting. Finally, this is a community that involves the saints in heaven and the Holy Family (fig. 27). In turn, these heavenly connections serve to validate the earthly community in many ways.

These are the unstated, omnipresent themes that I find in the traditional arts of Tucson's Mexicano community—arts that I have had the good fortune to be in contact with for about thirty years. No doubt others will find different ideas, different unifying devices. Their conclusions, too, will be valid. These arts constitute a rich tradition that has been insufficiently studied and little celebrated within our city. It is my hope that this situation will change, and that this book simply represents a stage in our expanding understanding and appreciation of those aesthetic traditions that have become much a vital part of our identity as a community and as a region.

Acknowledgments

1. The city of South Tucson is an independent political entity completely surrounded by the city of Tucson. It is on the southwest side of Tucson and has a large Mexican American, Tohono O'odham, and Yaqui population.

Chapter I. The Community

1. Definitions of traditional and folk arts are discussed in Teske (1982–83:34–38) and Griffith (1988).

2. An excellent account of Tucson's early history is given in Officer (1987). Details of Tucson's late nineteenth- and early twentieth-century history come from Sheridan (1986).

3. There are several scattered bits of evidence for the earlier English pronunciation of Tucson's name. One is a 1924 statement by Elders, which talks about the battle of Picacho Peak having taken place "between Tuckson, as it was then known, and the Gila River." Although Elders's claims to have been at the battle appear to be false, he was in Arizona in the 1870s and should have known how the city's name was pronounced.

4. A full discussion of El Tiradito appears as chapter 3 in Griffith (1995).

5. Notes and photographs concerning Mr. León are on file at the Southwest Folklore Center of the University of Arizona's library (hereafter "the Southwest Folklore Center") in Tucson.

6. Mr. Santa Cruz and his work are briefly discussed in Griffith (1988:136).

7. Anonymous, *Garden of Gethsemane/Felix Lucero Park,* leaflet (n.d.). Also see Weisman (1988:32–37).

8. The *quinceañera* is a celebration to mark a girl's coming of age in Mexican and Mexican American culture. It usually includes a Mass, a dance, and a dinner and is paid for by the girl's parents. The ceremony is often very formal, and the young woman may have several attendants. The girl wears a special corona, or crown, which in some communities is made by hand.

9. René Verdugo (1980).

10. For a biography of Lalo Guerrero, see Sonnichsen (1977). See also Loza (1993:158–83). In addition, the Southwest Folklore Center has an extensive collection of Guerrero's recordings and live performances as well as interviews with him.

11. One-page leaflet produced by El Poblano Salsa Company, on file in the Arizona Salsa Collection of the Southwest Folklore Center.

Chapter II. The Arts

Part 1. El Hogar/The Home

1. Our Lady of Guadalupe is the Virgin Mary as she appeared in 1531 to the Indian convert Juan Diego outside Mexico City. She is considered the patroness of Mexico,

"The Queen of the Americas," and her image appears in virtually every conceivable context among Mexican Americans. She is also known affectionately as *la Virgen morena* (the dark-complected Virgin). For an account of her apparition to Juan Diego, see Toor (1947:172–74). For an excellent account of the early history of the devotion to the Virgin of Guadalupe, see Poole (1995).

2. For further *deshilado* patterns and their names, see Siliceo Pauer (1920:73–75). For a description of the drawnwork (or "cutwork") tradition among Italian Americans, see Savareno (1981:39–44). For another handwork tradition in Mexican American communities along the border, see Cantú and Vela (1991).

3. The Holy Child of Atocha is the patron of miners and prisoners, among others. His popularity in the Mexican northwest probably stems partly from the importance of mining as a traditional occupation. See Lange (1978:3–7).

4. Saint Raymond Nonnatus (the "not-born") was delivered by a caesarian operation in Spanish Catalonia in 1204 A.D. While ransoming Christian slaves in Algiers, he was sentenced to impalement for converting Muslims to Christianity, but his sentence was reduced to running the gauntlet. After being tortured, he was ransomed and appointed Cardinal, but died on his way to Rome. He was canonized in 1657 and is the patron saint of midwives. His feast day is August 31. Delany (1980:487).

5. The Virgin of Montserrat is a dark statue of the Virgin and Child that is greatly venerated in Catalonia. According to tradition, it was carved from life by Saint Luke. See Nolan and Nolan (1989:93, 168, 202).

6. The Archangel Rafael is one of the three out of seven archangels who is identified by name in the scriptures. The other two are Michael and Gabriel. His name in Hebrew means "God Heals." Delany (1980:485).

7. Saint Anthony of Padua was a Franciscan who lived from 1195 to 1231 A.D. He was noted for the force and brilliance of his preaching as well as for his many miracles. He was canonized in 1232 A.D. and made a Doctor of the Church in 1946. A visitor once saw him holding the infant Jesus in his arms; he is usually shown thus in art. Delany (1980:63).

8. *Las posadas* (literally "the lodgings") is a processional reenactment of Joseph and Mary's search for lodging prior to the birth of Jesus. The procession winds through the streets, praying and singing, and pauses at prearranged houses to ask for shelter. They are turned away in song at all but the last house of the evening. Las posadas traditionally takes place on the nine nights before Christmas. Toor (1947:147–250) describes las posadas as they have been celebrated all over the Mexican world. Griffith (1988:28, 29) briefly describes the tradition as it exists in Tucson. The papers and photographs of Marguerite Collier, who introduced las posadas to Carrillo Elementary School in the 1930s, are on file at the Southwest Folklore Center.

9. January 6 is the Feast of the Epiphany (also known as the Day of the Three Kings and Twelfth Night) in the Catholic Church. It commemorates the arrival of the three magi bearing gifts for the infant Jesus, and therefore the moment when Christ's glory was revealed to the Gentile world. In many Catholic countries, gifts are traditionally exchanged on this day rather than on Christmas day itself. The Bible tells us only that three wise men came from afar bearing gifts; later medieval tradition supplies such details as their names—Caspar, Baltazar, and Melchior—as well as many of the familiar details of the nativity scene.

10. Candlemas is a traditional name for the February 2 feast, which is called the "Presentation of Our Lord" in the modern church calendar. It celebrates the day on which, according to tradition, the Virgin Mary was purified following her childbirth, and on which Jesus was presented at the Temple. The name "Candlemas" comes from the tradition of blessing candles on this day. Broderick (1976:90).

11. Waugh (1955) describes Mexicano Christmas rituals in San Antonio in the 1930s and 1940s. For contemporary Christmastime practices in Detroit's Mexican American community, see Sommers et al. (1995:113–45). See also Heisley and MacGregor-Villareal (1991).

12. For an introduction to Mexico's regional *tamal* traditions, see Kennedy (1972:84–103) and Bayless and Green Bayless (1987:175–92). For tamal (and other) recipes from the Tucson area, see Clark (1977). For an excellent overview of pre-Columbian Mexican foodways, see Coe (1994:1–119).

13. Pfefferkorn (1949:48–49).

14. An interesting discussion of the social meanings of men's cooking events in the barrios of San Antonio, Texas, may be found in Serif and Limón (1986:40–49).

15. Arriola (1981:96–105).

16. Kitchener (1987, 1994) and Ramos (1991:250–62).

17. Husband (1982, 1985), Vidaurri (1991a:222–49), and West (1991:163–77).

18. The Virgin of San Juan de los Lagos (Saint John of the Lakes) is an extremely popular devotion over much of northern Mexico and southern Texas. The devotion is said to have started in 1623, with the restoration to life of the daughter of a traveling acrobat. See Cruz (1993:323–26). San Juan de los Lagos is one of several shrines in Mexico that are associated with healing earth—in this case, white kaolin.

19. According to tradition, Saint Dymphna was the daughter of a pagan Celtic chieftain who had her and her religious companions murdered. Because miraculous cures were said to have occurred at her shrine involving epileptics, the insane, and those possessed, she is patroness of people suffering from epilepsy and mental illness. Delany (1980:188). Saint Francis Xavier was a Spanish Basque who became one of the original Jesuits. He worked in the Far East as a missionary and died in 1552 on an island off the coast of China. His remains were shipped to Goa, on the west coast of India; when they arrived there, it was found that the corpse was in a fresh and incorrupt state. For this reason, Saint Francis Xavier is occasionally represented as a reclining corpse. There is a strong and extremely complex folk devotion to this saint in northern Sonora and southern Arizona. For an overview of Saint Francis Xavier and his importance in the Pimería Alta, see Griffith (1992).

20. Egan (1991) and Octavec (1995).

Part 2. El Taller/The Workshop

21. The cross on the dome of San Xavier is depicted in Simmons and Turley (1980:166).

22. The Tumacacori Fiesta takes place on the first weekend in December at Tumacacori National Historic Park, forty-five miles south of Tucson on Interstate Highway 19. It is a celebration of the traditional cultures of the Santa Cruz Valley. The 4th Avenue Street Fair is a twice-yearly crafts fair sponsored by the 4th Avenue Merchants' Association.

90 • Notes

23. For an overview of Mexican American metalworking traditions in Texas, see Graham (1991b:19–23). See also Jasper and Turner, eds. (1986:69).

24. Mr. Osuna, owner of the shop, could not remember the name of the man who had made his door.

25. Many working-class Mexicanos wear tooled leather belts featuring floral designs and their first or last name in a panel across the back. It is this sort of belt that "Bambi" Gómez specialized in.

26. Anonymous (1986).

27. I know of no study of Mexican American furniture or furniture making, although photos of a workshop and finished pieces appear as figures 26 and 27 in Jasper and Turner (1986). Traditional Hispanic furniture making in northern New Mexico employs a different set of styles. This topic is well treated in Vedder (1982) and Taylor and Bokides (1987). For contemporary furniture making in the same region, see Baca (1995).

28. See Cox (1993) and Myal (1997/1999). Myal's excellent book (which was slightly out of date by the time it was published, so rapidly does the local restaurant scene change) attempts to list all of Tucson's Mexican restaurants and gives short histories of many of them.

29. The Catholic Church sets two days aside for the remembrance of the dead. November 1, All Saints' Day, is dedicated to those souls who are believed to be in the presence of God. November 2, All Souls' Day, focuses on the those souls who are still undergoing the cleansing process in Purgatory. In central and southern Mexico these holidays have been combined with traditional native beliefs and customs, and are referred to collectively as "los Días de los Muertos," or "the Days of the Dead." The Day of the Dead/All Souls' Day celebration as it takes place on the Arizona-Sonora borderlands mostly involves the cleaning and decorating of family graves. Griffith (1995:13–34).

30. Saints Crispin and Crispinian were third-century martyrs of the Christian Church. According to the legends, which provide virtually all we know concerning them, they were missionaries to Gaul who worked as shoemakers by night. They are the patrons of shoemakers and cobblers. Their day, October 25, is no longer celebrated in the official Catholic calendar. Delany (1980:163).

Part 3. La Comunidad/The Community

31. Griffith (1988, 1995) and Tunnell and Madrid (1991:131–45).

32. For accounts of Día de los Muertos as it is celebrated in central and southern Mexico, see Pomar (1987) and Carmichael and Sayer (1991). For the Day of the Dead as celebrated in Detroit, Michigan, see Sommers et al. (1995:35–64) and Valdez, ed. (1990). For a description of a contemporary Día de los Muertos celebration in Sacramento, California, see Hoyt-Goldsmith and Migdale (1994). This last book, aimed at children, describes public and private celebrations organized by an artist whose roots are in Michoacán.

33. See chapter 2 in Griffith (1995).

34. Griffith (1983:62–66) and (1988). For comparative Texas material, see Gallegos (1991).

35. For a definition of quinceañeras, see note #8 in chapter 1 above.

36. Chapter 1 in Griffith (1995) and West (1985:46–51).

37. Gradante (1985:70–77).

38. There is an excellent presentation of the Los Angeles parent chapter of The Dukes in the half-hour film, *Low and Slow: Three Generations of L.A. Lowriders,* produced by Monica Delgado Van Wagonen. For a discussion of open opposition to street gangs by low riders, see Anonymous (1996:92–97).

39. Sands (1993).

40. Miera (1994:24, 25) and Park (1991:167–71).

41. For a thoughtful discussion of some of the changes that can take place when a dance is adapted to *folklórico* uses, see Spicer (1965).

42. For an account of *concheros* in central Mexico in the mid-twentieth century, see Stone (1975).

43. Ronstadt (1993).

44. Peña (1985).

45. Saint Augustine was one of the great Doctors of the Church and, through such writings as his *Confessions* and *The City of God,* shaped the intellectual course of Western Christianity for more than a thousand years after his death in 430. Delany (1980:78–79). He is Tucson's formal patron and the patron of the Cathedral. His feast day, August 28, was a major Tucson holiday in the nineteenth century, until it was suppressed by the "respectable elements" of the town because of its increasing rowdiness. The fiesta was revived in the 1980s by the Arizona Historical Society as a celebration of Tucson's Hispanic roots.

46. There is a lot of literature on bilingual border humor in the Southwest. See, for instance, Reyna (n.d.) and Griffith (1995:4–6).

47. Henry (1991:C-1).

48. Anonymous (1993) and Cruz et al. (1980). A similar list of murals in El Paso can be found in Farrah and Juárez (1992). See also Kim (1995).

49. Turner (1993:B-5).

50. Recchio (1988:10).

51. Wagner (1993:B-3).

52. Anonymous (1997:96).

53. For a comprehensive photo-essay on memorial walls in New York, see Cooper and Sciorra (1994).

Chapter III. Patterns and Processes

1. Labels and other marketing materials from Arizona salsa companies are on file in the Southwest Folklore Center. Salsa in Tucson is discussed at greater length in Griffith (1995:9) and Cox (1993).

2. Parsons et al. (1999).

3. Chapter 8 in Griffith (1995) deals in some detail with the baroque legacy of Mexican American folk art in Tucson.

4. Vidaurri (1991b).

• Bibliography

Abernethy, Francis Edward, ed.
 1985 *Folk Art in Texas*. Publications of the Texas Folklore Society, XLV. Dallas: Southern Methodist University Press.

Anonymous
 n.d. *Garden of Gethsemane/Felix Lucero Park* (leaflet). Tucson: Downtown Development Corporation.
 1986 "Neon Bender/Sign Maker. This Artist's Work Shines All through the City," *Vocational Biographies,* series P, vol. 4. Sauk Center, Minn.: Vocational Biographies, Inc.
 1993 *Murals: Guide to Murals in Tucson.* Tucson: Tucson-Pima Arts Council.
 1996 *Borders and Identity: A Resource Guide for Teachers/Identidad y fronteras: una guía para maestros.* Washington, D.C.: Smithsonian Institution Center for Folklife Programs and Cultural Studies.
 1997 "Last Call," *Tucson Monthly* 1, no. 1 (September).

Arriola, Daniel D.
 1981 "Fences as Landscape Taste: Tucson's Barrios," *Journal of Cultural Geography* 2, no. 1 (fall/winter).

Baca, Elmo
 1995 *Rio Grande High Style Furniture Craftsmen.* Layton, Utah: Gibbs Smith.

Bayless, Rick, and Deann Green Bayless
 1987 *Authentic Mexican: Regional Cooking from the Heart of Mexico.* New York: William Morrow and Company.

Broderick, Robert C.
 1976 *The Catholic Encyclopedia.* Huntington, Ind.: Our Sunday Visitor.

Cantú, Norma, and Ofelia Zapata Vela
 1991 "The Mexican-American Quilting Tradition in Laredo, San Ygnacio, and Zapata," in *Hecho en Tejas: Texas-Mexican Folk Arts and Crafts* (Publications of the Texas Folklore Society, L), ed. Joe S. Graham. Denton: University of North Texas Press.

Carmichael, Elizabeth, and Chloe Sayer
 1991 *The Skeleton at the Feast: The Day of the Dead in Mexico.* Austin: University of Texas Press.

Clark, Amalia Ruíz
 1977 *Special Mexican Dishes, Simple and Easy to Prepare.* Tucson: Roadrunner Technical Publications.

Coe, Sophie D.
 1994 *America's First Cuisines.* Austin: University of Texas Press.

Cooper, Martha, and Joseph Sciorra
 1994 *R.I.P. Memorial Wall Art.* New York: Henry Holt and Company; an Owl Book.

Cox, Jay Anne

 1993 *Eating the Other: Mexican Food in Tucson, Arizona.* Ph.D. dissertation on file at the University of Arizona Library, Tucson.

Cruz, Frank, and the staff of the Sonoran Heritage Project

 1980 *The Power of Cultural Identity. Sonoran Heritage: Mexican-American Mural Art* (brochure prepared for the Sonoran Heritage Project). Tucson: Tucson Public Library.

Cruz, Jean Carrol

 1993 *Miraculous Images of Our Lady. 100 Famous Catholic Portraits and Statues.* Rockford, Ill.: Tan Books and Publishers.

Delany, John J.

 1980 *Dictionary of Saints.* Garden City, N.J.: Doubleday and Company.

Egan, Martha

 1991 *Milagros: Votive Offerings from the Americas.* Santa Fe: Museum of New Mexico Press.

Elders, M. M.

 1924 Statement in *The Arizona Republican* (Phoenix), 9 April.

Farrah, Cynthia, and Miguel Juárez

 1992 *Los Murales: Guide and Maps to the Murals of El Paso.* El Paso, Tex.: The Junior League of El Paso, Inc.

Gallegos, Esperanza

 1991 "The Piñata-Making Tradition in Laredo," in *Hecho en Tejas: Texas-Mexican Folk Arts and Crafts* (Publications of the Texas Folklore Society, L), ed. Joe S. Graham. Denton: University of North Texas Press.

Gradante, Bill

 1985 "Art Among the Low Riders," in *Folk Art in Texas* (Publications of the Texas Folklore Society, XLV), ed. Francis Edward Abernethy. Dallas: Southern Methodist University.

Graham, Joe S., ed.

 1991a *Hecho en Tejas: Texas-Mexican Folk Arts and Crafts* (Publications of the Texas Folklore Society, L). Denton: University of North Texas Press.

 1991b "Hecho a mano en Tejas—Hand Made in Texas," in *Hecho en Tejas: Texas-Mexican Folk Arts and Crafts* (Publications of the Texas Folklore Society, L), ed. Joe S. Graham. Denton: University of North Texas Press.

Griffith, James S.

 1983 "Ernesto and Gloria Delgadillo: Professional Piñata Makers," in *Traditional Craftsmanship in America,* ed. Charles Camp. Washington, D.C.: National Council for the Traditional Arts.

 1988 *Southern Arizona Folk Arts.* Tucson: University of Arizona Press.

 1992 *Beliefs and Holy Places: A Spiritual Geography of the Pimería Alta.* Tucson: University of Arizona Press.

 1995 *A Shared Space: Folklife of the Arizona-Sonora Borderlands.* Logan: Utah State University Press.

Heisley, Michael, and Mary MacGregor-Villareal

 1991 *More than a Tradition: Mexican American Nacimientos in Los Angeles.* Los Angeles: The Southwest Museum.

Henry, Bonnie
 1991 "Artist from Sonora Has Baptism at ASU, but Flowers in Tucson," *The Arizona Daily Star,* 5 September. Tucson: Tucson Newspapers, Inc.
Hoyt-Goldsmith, Diane; photographs by Lawrence Migdale
 1994 *Day of the Dead: A Mexican-American Celebration.* New York: Holiday House.
Husband, Eliza
 1982 "Yard Shrines and Hispanic Culture in Tucson: A Preliminary Survey." Term paper on file at the Southwest Folklore Center, University of Arizona, Tucson.
 1985 "Geography of a Symbol: Hispanic Yard Shrines of Tucson, Arizona." Masters thesis on file at the University of Arizona Library, Tucson.
Jasper, Pat, and Kay Turner, eds.
 1986 *Art Among Us/Arte entre nosotros: Mexican-American Folk Art of San Antonio* (catalogue of exhibition, 27 April–15 June). San Antonio: The San Antonio Museum of Art.
Kennedy, Diana
 1972 *The Cuisines of Mexico.* New York: Harper and Row.
Kim, Sojin
 1995 *Chicano Graffiti and Murals: The Neighborhood Art of Peter Quezada.* Jackson, Miss.: University Press of Mississippi.
Kitchener, Amy
 1987 "Windows into the Past: Mexican-American Yardscapes in the Southwest." Senior honors thesis on file at the Southwest Folklore Center, University of Arizona, Tucson.
 1994 *The Holiday Yards of Florencio Morales, "El Hombre de las Banderas."* Jackson: University Press of Mississippi.
Lange, Yvonne
 1978 "Santo Niño de Atocha: A Mexican Cult is Transplanted to Spain." *El Palacio* 84, no. 4 (winter). Santa Fe: Museum of New Mexico.
Loza, Steven
 1993 *Barrio Rhythm: Mexican-American Music in Los Angeles.* Urbana: University of Illinois Press.
Miera, Rudy J.
 1994 "Paño Art Draws on Expression," *La Herencia del Norte: Our Past, Our Present, Our Future* IV (winter). Santa Fe: Gran Via, Inc.
Myal, Suzanne
 1997 *Tucson's Mexican-American Restaurants. Repasts, Recipes, Remembrances.* Tucson: Fiesta Publishing. (Reprinted by University of Arizona Press, 1999.)
Nolan, Mary Lee, and Sidney Nolan
 1989 *Christian Pilgrimage in Modern Western Europe.* Chapel Hill: University of North Carolina Press.
Octavec, Eileen
 1995 *Answered Prayers: Miracles and Milagros along the Border.* Tucson: University of Arizona Press.
Officer, James E.
 1987 *Hispanic Arizona, 1536–1856.* Tucson: University of Arizona Press.

Park, Glenna A. Stearman

 1991 "Jailhouse Rag," in *Folk Art in Texas* (Publications of the Texas Folklore Society, XLV), ed. Francis Edward Abernethy. Dallas: Southern Methodist University.

Parsons, Jack (photographs), Carmella Padilla (text), and Juan Estevan Arrellano (poetry)

 1999 *Low 'n Slow: Lowriding in New Mexico.* Santa Fe: Museum of New Mexico Press.

Peña, Manuel H.

 1985 *The Texas-Mexican Conjunto: History of a Working Class Music.* Austin: University of Texas Press.

Pfefferkorn, Ignatz

 1949 "Sonora: A Description of the Province," trans. and ed. Theodore Trautlein, *Coronado Cuatro Centennial Publications* 3. Albuquerque: University of New Mexico Press.

Pomar, María Teresa

 1987 *El Día de los Muertos: The Life of the Dead in Mexican Folk Art.* Fort Worth: The Fort Worth Art Museum.

Poole, Stafford C. M.

 1995 *Our Lady of Guadalupe, The Origins and Sources of a Mexican National Symbol, 1531–1797.* Tucson: University of Arizona Press.

Ramos, Eric

 1991 "Mexican-American Yard Art in Kingsville," in *Hecho en Tejas: Texas-Mexican Folk Arts and Crafts* (Publications of the Texas Folklore Society, L), ed. Joe S. Graham. Denton: University of North Texas Press.

Recchio, Shelly

 1988 "Hispanic Artist Displays Wall Works," *El Independiente* (March). Tucson: University of Arizona Journalism Department.

Reyna, José R.

 n.d. *Raza Humor: Chicano Joke Tradition in Texas.* San Antonio: Penca Books.

Ronstadt, Edward F., ed.

 1993 *Borderman: Memoirs of Federico José María Ronstadt.* Albuquerque: University of New Mexico Press.

Sands, Kathleen

 1993 *Charrería Mexicana: An Equestrian Folk Tradition.* Tucson: University of Arizona Press.

Savareno, Joan

 1981 "Ana Guarascio Peluso: Preserving an Italian Art in West Virginia," *Goldenseal* 7, no. 4 (winter).

Serif, Suzanne, and José Limón

 1986 "Bits and Pieces: The Mexican-American Folk Aesthetic," in *Art Among Us/ Arte entre nosotros: Mexican-American Folk Art of San Antonio* (catalogue of exhibition, 27 April–15 June), eds. Pat Jasper and Kay Turner. San Antonio: The San Antonio Museum of Art.

Sheridan, Thomas

 1986 *Los Tucsonenses.* Tucson: University of Arizona Press.

Siliceo Pauer, Paul
 1920 "Deshilados colectadas en México, D.F., por el Sr. Paul Siliceo Pauer; dibujados por el Sr. Luís Nuñez Plumet," *Journal of American Folklore* 33.
Simmons, Marc and Frank Turley
 1980 *Southwestern Colonial Ironwork: The Spanish Blacksmithing Tradition from Texas to California.* Santa Fe: Museum of New Mexico Press.
Sommers, Laurie Kay, in collaboration with Casa de Unidad Cultural Arts and Media Center
 1995 *Fiesta, fe, y cultura: Celebrations of Faith and Culture in Detroit's Colonia Mexicana.* Detroit: Casa de Unidad Cultural Arts and Media Center, and East Lansing: Michigan State University Museum.
Sonnichsen, Philip
 1977 "Lalo Guerrero, Pioneer in Mexican-American Music," *La Luz* (May). Published by the League of United Latin American Citizens.
Spicer, Edward H.
 1965 "La danza Yaqui del venado en la cultura mexicana," *América Indígena* XXV, no. 1.
Stone, Martha
 1975 *At the Sign of Midnight: The Concheros Dance Cult of Mexico.* Tucson: University of Arizona Press.
Taylor, Lonn, and Dessa Bokides
 1987 *New Mexican Furniture, 1600–1940: The Origins, Survival, and Revival of Furniture Making in the Hispanic Southwest.* Santa Fe: The Museum of New Mexico Press.
Teske, Robert
 1982–83 "What is Folk Art? An Opinion on the Controversy," *El Palacio* 88, no. 4 (winter). Santa Fe: The Museum of New Mexico.
Toor, Frances
 1947 *Mexican Folkways.* New York: Crown Publishers.
Tunnell, Curtis, and Enrique Madrid
 1991 "Coronas para los muertos, The Fine Art of Making Paper Flowers," in *Hecho en Tejas: Texas-Mexican Folk Arts and Crafts* (Publications of the Texas Folklore Society, L), ed. Joe S. Graham. Denton: North Texas University Press.
Turner, Tom
 1993 "Tineo Sees Art as Unifying Force for Youth," *The Arizona Daily Star,* 13 August. Tucson: Tucson Newspapers, Inc.
Valdez, Margarita
 1990 *Tradiciones del pueblo, Traditions of Three Mexican Feast Days in Southwest Detroit.* Detroit: Casa de Unidad Cultural Arts and Media Center.
Vedder, Alan C.
 1982 *Furniture of Spanish New Mexico.* Santa Fe: The Sunstone Press.
Verdugo, René
 1980 *Copper Cut-outs by Emilio Sánchez Eldridge* (catalogue of exhibition, 4 May–15 June). Tucson: Tucson Museum of Art.

Vidaurri, Cynthia

 1991a "Texas-Mexican Religious Folk Art in Robstown, Texas," in *Hecho en Tejas: Texas-Mexican Folk Arts and Crafts* (Publications of the Texas Folklore Society, L), ed. Joe S. Graham. Denton: University of North Texas Press.

 1991b *The Mexican-American Religious Folk Art Traditions in South Texas.* Masters thesis, Texas A&I, Kingsville.

Wagner, Raina

 1993 "Budding Artist Helps Fight Graffiti," *The Arizona Daily Star* (Tucson), 14 June.

Waugh, Julia Nott

 1955 *The Silver Cradle.* Austin: University of Texas Press.

Weisman, Alan

 1988 "Arizona's Shrine to St. Joseph," *Arizona Highways* (June). Phoenix: Arizona State Highway Department.

West, John O.

 1985 "Folk Grave Decoration along the Rio Grande," in *Folk Art in Texas* (Publications of the Texas Folklore Society, XLV), ed. Francis Edward Abernethy. Dallas: Southern Methodist University Press.

 1991 "Grutas in the Spanish Southwest," in *Hecho en Tejas: Texas-Mexican Arts and Crafts* (Publications of the Texas Folklore Society, L), ed. Joe S. Graham. Denton: University of North Texas Press.

For names with double surnames, alphabetization is under the second name.

• About the Author

Jim Griffith was born in southern California but has called Tucson home since 1963. Now retired, after almost twenty years of directing the University of Arizona's Southwest Folklore Center, he continues to study and document the traditional arts and customs of southern Arizona and northern Sonora. He is currently a Research Associate at the University of Arizona's Southwest Studies Center. His previous books are *Southern Arizona Folk Arts* and *Beliefs and Holy Places*, both from the University of Arizona Press, and *A Shared Space,* from the Utah State University Press.